Malcolm Morley
in Full Colour

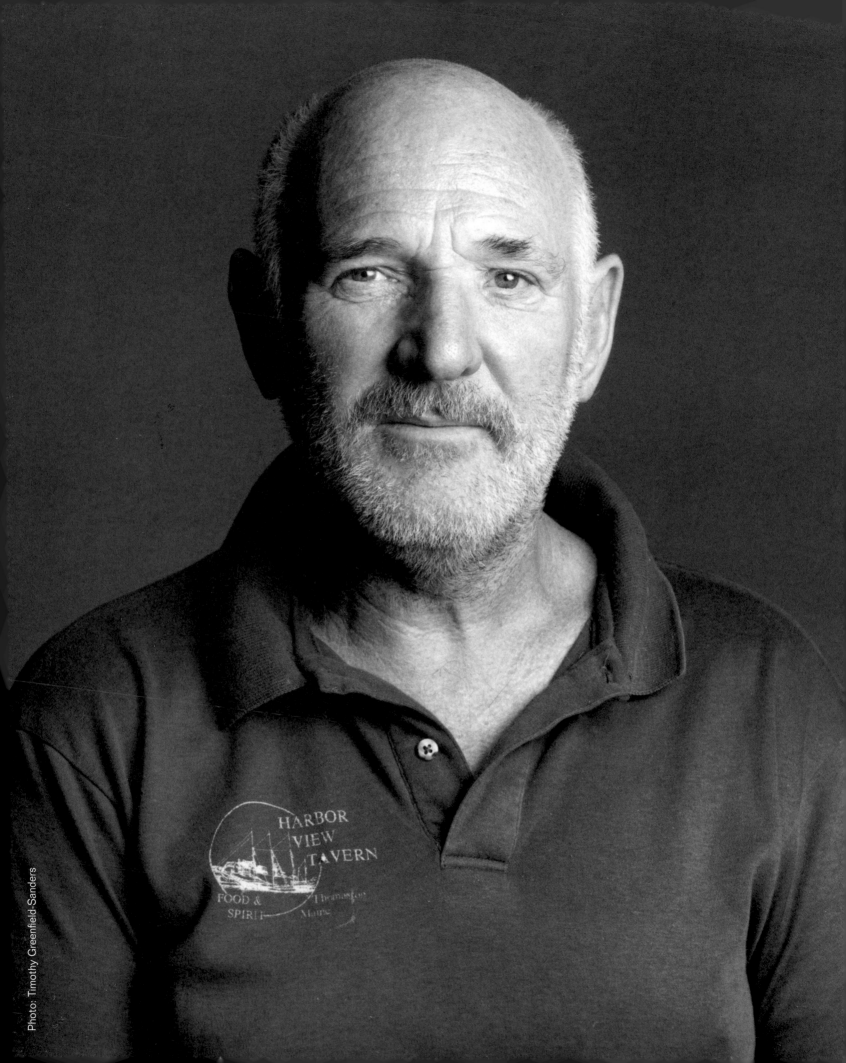

Malcolm Morley
in Full Colour

Sarah Whitfield

Hayward Gallery

sbc

Published on the occasion of the exhibition *Malcolm Morley in Full Colour*, organized by the Hayward Gallery, London, 15 June – 27 August 2001

Exhibition selected by Sarah Whitfield
Exhibition organized by Clare Carolin, assisted by Stuart Tulloch

Architectural design by David Dernie Architects

Exhibition sponsored by

Catalogue designed by Herman Lelie
Typeset by Stefania Bonelli
Printed in England by P.J. Print

Cover: *French Navy*, 1964 (cat. 6)
Frontispiece: Timothy Greenfield-Sanders, *Portrait of Malcolm Morley*, 1990
 Courtesy: Anthony d'Offay Gallery
Published by Hayward Gallery Publishing, London SE1 8XX, UK
© Hayward Gallery 2001
Texts © Sarah Whitfield 2001
Interview © Malcolm Morley and Hayward Gallery 2001
Artworks © Malcolm Morley 2001 (unless stated otherwise)

ISBN 1 85332 217 2

Hayward Gallery Publishing titles are distributed outside North and South America and Canada by Cornerhouse Publications, 70 Oxford Street, Manchester M1 5NH
(tel. 0161 200 1503; fax. 0161 200 1504).

Contents

Preface

This exhibition, in the year of Malcolm Morley's seventieth birthday, celebrates a lifetime of remarkable achievement. Morley is an artist whose forty-year career has been distinguished by two fundamental characteristics: first, a great technical virtuosity coupled with a commitment to pushing painting to its limits; and, second, the courage and conviction with which he has embraced change in order to pursue this objective. In charting the dramatic development of Morley's art from the 1960s to the present day, it is our hope that this exhibition will provide visitors not only with an insight into the unique vision of an exceptional individual, but also with an understanding of the multitudinous ways in which a changing world can be seen and represented.

An Englishman by birth, Morley left for the United States in the 1950s. He is credited as the initiator of two significant and very different movements: Photo-Realism in the 1960s, and Neo-Expressionism in the 1980s. In 1984 he was the first winner of the Turner Prize, and he is now widely acknowledged as one of the great figures of contemporary painting. Yet despite these achievements, and although he has had several prestigious exhibitions in Europe over the past ten years, the last significant showing of his work in Britain was at the Whitechapel Art Gallery as long ago as 1983. Since then, painting has once again become paramount for a new generation of artists, and it is thus with a keen sense of anticipation that we present Morley's work to a new audience, and works of his not previously seen to those already initiated.

Above all, our thanks go to Malcolm Morley for making this exhibition possible and for collaborating so closely with us on its realization. The hospitality with which he has received us in his home and his good-humoured responses to our numerous requests and enquiries are very greatly appreciated. We also extend our heartfelt thanks to Morley's wife Lida, whose support, encouragement and practical assistance have been invaluable.

The idea for a retrospective of Malcolm Morley's painting was presented to us by Sarah Whitfield, who collaborated with the Hayward Gallery most recently on *Lucio Fontana* in 1999. As always, it has been an immense pleasure to work with her. The breadth of knowledge she has brought to bear on the project, and her scrupulous attention to every detail, have been impressive. We thank her also for the thorough and insightful text which appears in this catalogue, as we do Martin Gayford for his illuminating interview with the artist.

8

We are immensely grateful to the owners of Morley's work who have responded so promptly and generously to our loan requests, and who have helped us to resolve various issues arising from the practicalities of each loan. Our appreciation therefore goes to Astrup Fearnley Museum of Modern Art; Baldwin Gallery, Aspen; Lori and Marc Barron; Guy and Nora Barron; Irma and Norman Braman; Eli and Edythe L. Broad; Centraal Museum, Utrecht; Columbus Museum of Art, Ohio; Anne and Anthony d'Offay; The Detroit Institute of Arts; Stefan T. Edlis; Marieluise Hessel; Hirshhorn Museum and Sculpture Garden, Smithsonian Institution; Mel Juffe; Robert Lehrman; Louisiana Museum of Modern Art; Ludwig Museum, Budapest; Mitchell-Innes & Nash, New York; The Museum of Modern Art, New York; PaceWildenstein, New York; Musée national d'art moderne, Centre Georges Pompidou; Reinhard Onnasch Kunsthandel; Tate Gallery; Wadsworth Atheneum; Virginia and Bagley Wright and Xavier Hufkens, Brussels, as well as to those lenders who wish to remain anonymous.

We would also like to express particular thanks to Angela Westwater and her colleagues at Sperone Westwater Gallery, whose consistent support, cooperation and knowledge of Morley's work has been of tremendous benefit to this project from the outset.

Our thanks go too to Herman Lelie and Stefania Bonelli for designing this book, to Linda Schofield, the Hayward's Art Publisher, for her rigorous attention to its editing and production needs, and to Caroline Wetherilt, the Hayward's Publishing Coordinator, for her assistance throughout.

David Dernie designed the installation architecture, and we are grateful to him for his patience and sensitivity. My thanks also go to Keith Hardy, the Hayward's Head of Operations, to Mark King, its Installation Manager, and his crew, and to Imogen Winter, our Registrar, for ensuring the successful realization of the show within the Hayward Gallery. The show's lighting owes its success to John Johnson and his team at Lightwaves Ltd.

Particular mention must also be made of Lucy Bryn Davies, Keith Courtney, Antonia Harrison and Rob Janowski of Publicis, our advertising agency, for their involvement and continued support in this project.

We should also like to acknowledge Carol George, Catherine Grenier, Xavier Hufkens, Maria Kilcoyne, Peter Krashes, Jean-Claude Lebensztejn, Bill Mackinnon, Tobias Meyer, Frank Millman, Lucy Mitchell-Innes, Karen Polack, Nicholas Serota, Evelyn Weiss, Cheyenne Westphal and Johan de Zoete, for the advice and support they have given us as the exhibition has evolved.

Not least, I extend my warmest thanks to those people at the Hayward Gallery who have embraced this project from its inception and who have played a vital and indispensable role in its realization: Felicity Allen, the Hayward's Head of Public Programmes and Sarah Lee, Public Programmes Assistant; Alex Hinton and Claire Eva in Hayward Marketing; Alison Wright, our Press Relations Manager and Ann Berni, Press Relations Coordinator; Pamela Griffin, our Information Officer; and Martin Caiger-Smith, the Hayward's Head of Exhibitions. To Clare Carolin, the Hayward's Exhibitions Curator responsible for the project, and her assistant Stuart Tulloch, very special thanks for their anticipation of its every need and their wholehearted engagement with it.

Susan Ferleger Brades
Director, Hayward Gallery

Malcolm Morley: Paintings 1961 – 2001

1961 – 1964

'What you take with you becomes wonderfully valuable elsewhere.'[1]

The way Morley's career has unfolded – one distinct, self-contained phase followed by another and then another – shows him to be an artist who has never hesitated to go against the grain of what he has done before. Propelled by the urge to move on, by the conviction that life is an urgent business and that his painting should reflect that urgency, he hasn't bothered too much with those who have difficulty in keeping up with the shifts and changes. 'An artist is testing where you can go', he said recently, 'the path is always behind, it's never in front because there is no path. The path is where one's been.'

Moving on began early. Morley left England when he was twenty-seven years old. That was in 1958, a moment when a young ambitious graduate of London's Royal College of Art might well have thought that the most invigorating art of the moment was to be found, not in London, but in New York. Two years earlier, Morley had been able to see a broad range of contemporary American art when *Modern Art in the United States*, a major touring exhibition organized by The Museum of Modern Art in New York, came to the Tate Gallery London. Because there were so few opportunities then to see contemporary American painting, much has been made of the impact that show had on Morley, but recently the painter told his friend Jean-Claude Lebensztejn that, far from being overwhelmed by what he saw, his response to the exhibition was mixed. 'My ambition was too big', he said, 'I would have liked to be Pollock but I wouldn't want to be after Pollock'.[2] As it turned out, romance rather than ambition swept him off to America, but once in New York, there was no looking back. Within months of that first visit, he was living there.

Aesop's Fables (cat. 1), the earliest work in the exhibition, was painted in 1961 when Morley had been in New York for about three years. It belongs to the Wadsworth Athenaeum in Hartford, Connecticut, where it shares a room with works by four other painters: Jackson Pollock, Clyfford Still, Mark Rothko and Adolph Gottlieb. Surrounded by this hard-hitting, all-American team, it looks perfectly at ease. The canvas is large and the handling of the painterly surface exudes the tough self-confidence of a young artist

sizing up the competition. At the forefront of that competition was another painter, Willem de Kooning, for many at that time the most influential painter alive. The cloudy whiteness of *Aesop's Fables* is made up of soft colours, green, pink and yellow. These are colours that bring the paintings of de Kooning to mind, just as the surface breaks up into the highly evocative abstract shapes found in de Kooning's urban paintings of the late 1950s. The necklace in cat. 2, stands out against the loosely-defined naked body with a sudden flash of clarity, not unlike the rows of white teeth that flash from de Kooning's *Woman and Bicycle*, 1952–53. *Necklace*, 1961–62 (cat. 2) is a painting of a torso seen from above, or rather, gazed at from above, the area between the pelvis and the throat flattened out like a spatch-cocked bird. Naturalistic details are kept to a minimum, a nipple on the left-hand side, the hint of a raised arm on the right, a belly-button sinking into the flesh in the centre. The eye is kept busy reading abstract shapes as naturalistic forms while simultaneously encouraged to translate them back into abstraction. As de Kooning said, 'even abstract shapes must have a likeness'.[3] The question of likeness, however, can be problematic. When Morley was shown photographs of the works selected for the present exhibition, he expressed surprise at the upright format of *Aesop's Fables* even though the format is confirmed by the placing of the signature. 'I don't know if that is the way I would have wanted it necessarily', he said. 'It has such a figure look to it that way. I prefer it this way, don't you? (turning the photograph on its side). I seem to get a better reading of it here. It's too tall the other way, it looks like a figure, with a head and two legs'. Pointing out that the painting hangs that way in the Wadsworth Athenaeum, I remarked that if it were hung on its side the forms that emerge out of the paint like parts of a boat appearing and disappearing in a mist would be lost. 'What boat?', Morley demanded, 'There is no boat'.

The title of *Submarine*, 1962 (cat. 4) permits a reading of the image in a way that *Aesop's Fables* does not. The surface may appear flatter but the line cutting through the centre like the shaft of a periscope draws us slowly down through the painting. On the left-hand edge of the canvas, half-way down, is a suggestion of a hull. Look straight across to the right, and down a little and there on the edge is the outline of a boat. These small black shapes, unmistakably nautical, are delicate intrusions into abstract territory. The same refinement can be seen in the passages of light pencil scribbles under the paint, similar to the scurrying pencil marks that Morley liked so much in the paintings of Cy Twombly. 'I was very taken with all that graffiti', he said recently. The way Morley

fig. 1
Robert Ryman
*Untitled, c.*1963

forces thick pigment through the nozzle of a pastry gun to create a decorative crust on the surface (cat. 4) suggests that he was also very taken with the early paintings of Robert Ryman (fig. 1).

The most abstract of these early paintings turns out to have been inspired by realism on a spectacular scale. Eisenstein's 1938 epic, *Alexander Nevsky*, made a lasting impression on Morley when he saw it in New York, in particular the scene in which the invading Teutonic knights are driven into the weak ice of a frozen river and drown (fig. 2). This, he tells us, was one of the starting points for cat. 3 and he describes how the highly formalized naturalism of Eisenstein's imagery of drowning men and horses has been translated into the language of paint: 'you can see the cracking and those cracks being filled up with all kind of scribble inside and pastel chalk and lots of stuff'. What he didn't mention, but which can be inferred from the painting's restricted colour, is the impression made on him by Eisenstein's masterly use of the black and white medium of film to convey the starkness of the glaring white ice with the fathomless black of the water beneath. The

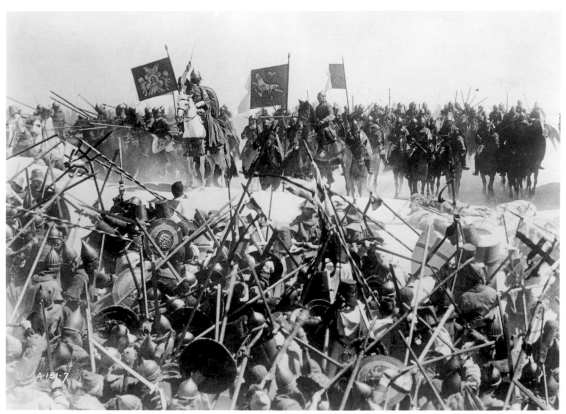

fig. 2
still from *Alexander Nevsky*, 1938

connection with Eisenstein's film is extremely telling. Conflict and catastrophe, frenzy and cruelty, the elements that make up the epic tale of Alexander Nevsky are also elements that have their place in Morley's subject matter. These are the experiences he most identifies with because, as he explains, they were the experiences he grew up with. 'I was subject to bombing and brought up on war films.'[4]

Aesop's Fables may look comfortable with American art of a certain vintage, but there is something about it that sets it apart. Barnett Newman, whom Morley had met while waiting tables in a New York restaurant and who subsequently became a friend and mentor, put his finger on it when he complimented Morley one day on the light in his paintings.[5] It is not a light that skims over the surface but a light that seems to be contained within the layers of paint. The pale expanses of Cy Twombly's early canvases, which have a similar quality of interior light, may well have caught Morley's attention, but the churning

turbulence of the paint, which, combined with the sinking weight of deep water, recalls a painter much closer to Morley's English roots, Turner. In February 1961, the year Morley painted *Aesop's Fables*, Robert Rosenblum famously coined the term 'The Abstract Sublime', placing the Abstract Expressionist painters within the broader context of the European Romantic tradition, comparing Pollock and Rothko, for instance, to Casper David Friedrich, Turner and John Martin.[6] Even though the surface of *Aesop's Fables* holds together, it is not contained; the forms extend beyond the boundaries of the canvas as though respecting the boundlessness of the oceans. This is its bond with the Romantic tradition, with the English Romantic tradition in particular, and explains in part why this painting, singular as it is, settles down so comfortably with paintings by Rothko, Pollock and Still. 'What you take with you', Morley once said, 'becomes wonderfully valuable elsewhere.'

1
Aesop's Fables, 1961

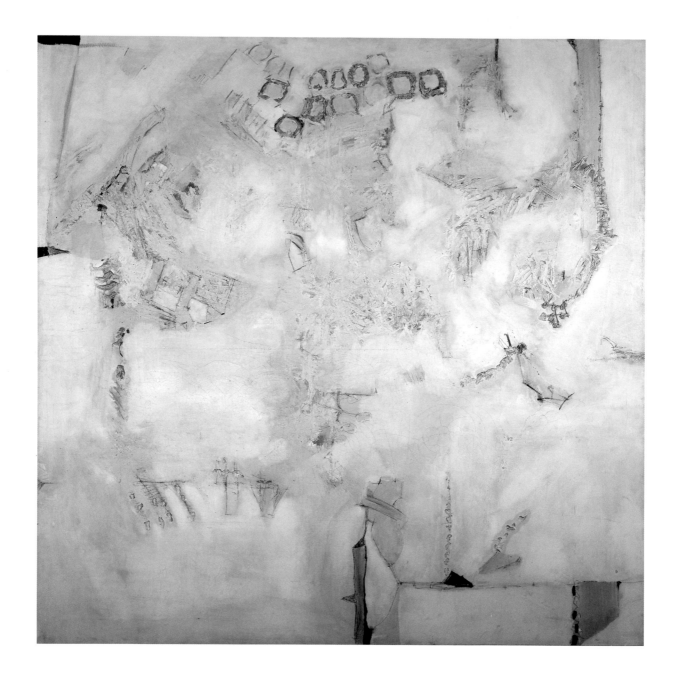

2
Necklace, 1961–62

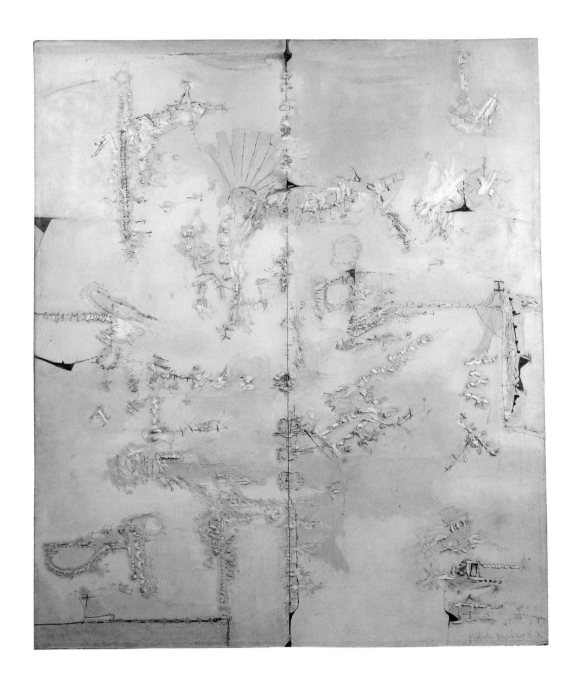

4
Submarine, 1962

3
Alexander Nevsky, 1962

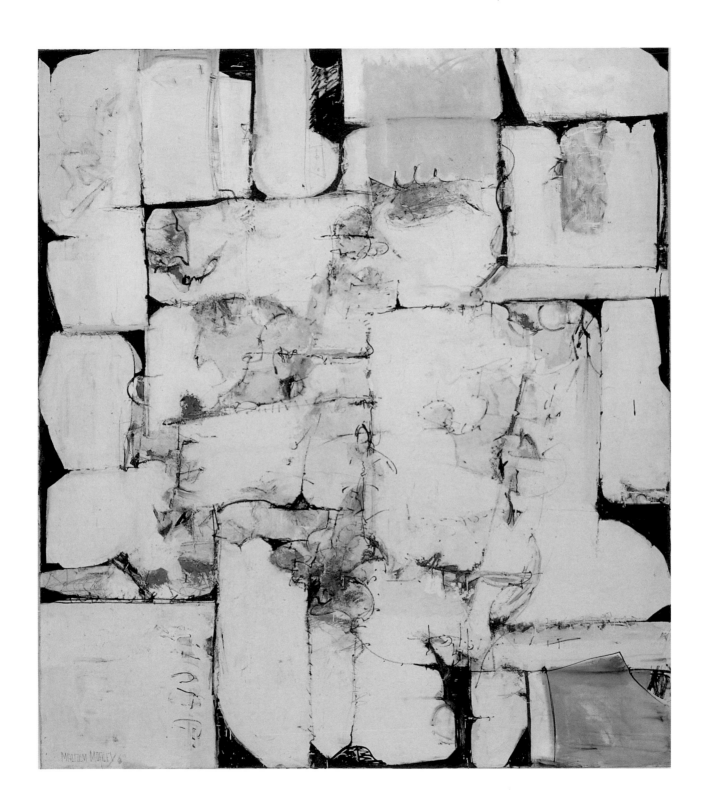

5
Malcolm Morley at the Seaside, 1963

7
Ideal State: The New Atlantis F.B., 1964

1964 — 1965

'There was a terrible feeling in New York that everybody had occupied an object. Warhol had the Coke bottle, and everybody had a certain thing, you know, and I was still up in the air.'

Morley's arrival in New York coincided with a seismic shift in American art. The turbulence and impulsiveness of the Abstract Expressionists was being challenged by an art of heraldic coolness and clarity. The flags and targets of Jasper Johns, for example, the black paintings of Frank Stella, the Ben Day dot paintings of Roy Lichtenstein, the Campbell's Soup cans and Coca-Cola bottles of Andy Warhol — works of immense authority and conviction — slammed into the art of de Kooning and Pollock as if out of nowhere. New artistic territories were quickly staked out and Morley was not alone in his perception that everybody in New York had 'occupied an object'. A few years earlier Warhol too had felt the pressure and had stopped doing comic strip paintings the moment a friend showed him the paintings Roy Lichtenstein had done from cartoons. 'From the point of view of strategy and military installation, you were of course correct', Henry Geldzhaler told Warhol, 'that territory had been pre-empted.'[7]

The fierceness of the territorial claims makes the authority of Morley's first realist paintings (cat. 6, 8 – 10) all the more impressive. They betray none of the doubts expressed in retrospect, none of the tentativeness one might expect from a young artist up against the competition. With hindsight, though, it is easy to see that Morley's subject was already sliding into place. The abstract paintings of the early 1960s had been about the sea and about being on the sea.[8] Even a painting as severely abstract as *Ideal State: The New Atlantis F.B.*, 1964 (cat. 7) is no exception, for while there is no overt reference to water or to motion, the black rubber of the inner tube that separates the two panels brings to mind the old car tyres slung over the quayside to protect the sides of boats.

Morley sold *Ideal State* to Florence Barron (the F.B. in the title), an interior decorator from Detroit with a zeal for searching out young artists and commissioning work from

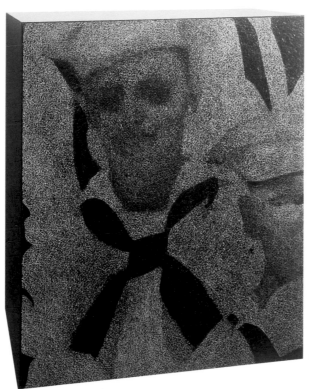

fig. 3
Richard Artschwager
Sailors, 1964

them.[9] One of her discoveries was Richard Artschwager and she took Morley to meet
him. As he walked into Artschwager's studio he was amazed to see him drawing a charcoal
grid on a sheet of Celotex. Squaring up a drawing (or in this case, a photograph) and
transposing it on to canvas or some other support was an exercise very familiar to Morley
from his days at Camberwell School of Art. As he now recognizes, 'William Coldstream
and Camberwell, all that really helped. It was the English version of Cubism.' For the
past four years or so Artschwager had been using the structure of the grid to make grisaille
paintings from black and white photographs (after discovering a discarded snapshot in a
pile of street rubbish). The effect on Morley was immediate. *French Navy,* 1964 (cat.6),
which is very close to Artschwager both in subject matter and technique (fig. 3), is painted
using Higgins Ink on a prepared canvas, a medium that emulates the murky effects of a
poor quality newspaper photograph. At the same time, Morley had become 'very much
enamoured', as he put it, with another photo-based art. His admiration for Warhol's first
silkscreen paintings is openly expressed in the two versions of *HMS Hood*. In one, *HMS
Hood, Foe,* 1965 (cat. 8), the image is muffled by the layers of black ink, so that it appears

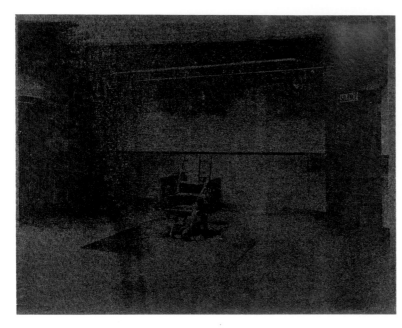

fig. 4
Andy Warhol
Little Electric Chair, 1965

to loom out of the sea, silent and threatening, just as Warhol's electric chair (fig. 4) looms out of the death chamber. Its pair, *HMS Hood, Friend*, 1965 (cat. 9), is suffused in red, a direct reference to Warhol's use of monochrome as in, for example, *5 Deaths on Red*, 1962. If *French Navy* is like a hand-painted newspaper photograph, the two versions of *HMS Hood* are like hand-painted silkscreens. The choice of image, which Morley has called 'the dreadnought look', goes back to a childhood obsession, the black and white photographs which filled the pages of the old copies of *The Illustrated London News* kept in his grandmother's trunk (fig. 5).

The photograph of HMS Hood was taken from a book Morley found in a New York library and shows the battle cruiser (launched in 1918) before she had been fitted out for service in the Second World War. When the ship, the pride of Britain's war fleet, was sunk by a U-boat in May 1941, Morley was a few weeks short of his tenth birthday. The loss shook the nation's nerve and must have stirred up bad memories for Morley's family. The painter's maternal grandfather, Austin Clement Morley, had been killed in 1918 when the armed boarding steamer on which he served as a stoker received a direct hit from a U-boat and sank in the North Sea.

Like Artschwager, Morley began to make use of the grid in order to divide the news-paper photograph into small manageable areas that could be reproduced on the canvas.

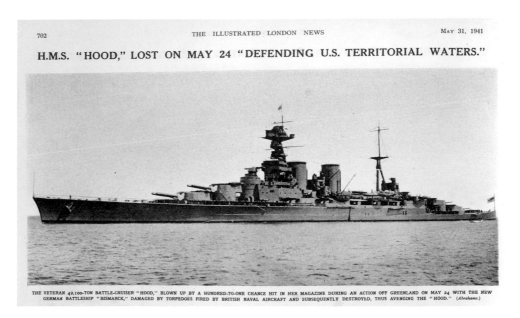

fig. 5 *The Illustrated London News*, 31 May 1941

Recently, looking at a photograph of *Alexander Nevsky*, 1962 (cat. 3), Morley was struck by how the planes of colour, even then, were beginning to break down into a grid-like structure. By the early 1960s, finding a system of ordering had become the preoccupation of a number of young artists. The repeated squares of Warhol's silkscreened photographs, the strict divisions of Agnes Martin's paintings, the modular units of Carl Andre, these are all works in which the grid is made an assertive part of the whole. In Morley's paintings, on the other hand, the grid is made to disappear in the traditional manner (as it is in the paintings of Walter Sickert, for example, or Stanley Spencer). In other words, for a number of young American painters and sculptors working in the late 1950s and early '60s, the answer to the problem of balancing the various parts of a work of art with and against each other was symmetry – making it the same all over. Symmetry brought rigour to the painting process which is why Morley likens his grid to grammar: 'It's the equivalent of language', he says, 'it doesn't lie; it's like a measuring rod.' Taking pleasure in working within a strict set of rules had been part of Morley's training long before he became an art student. The exacting demands of making model ships and airplanes had been a childhood passion and among the skills he enjoyed learning at Hewel Grange Reformatory School, he tells us, were bricklaying and weaving.

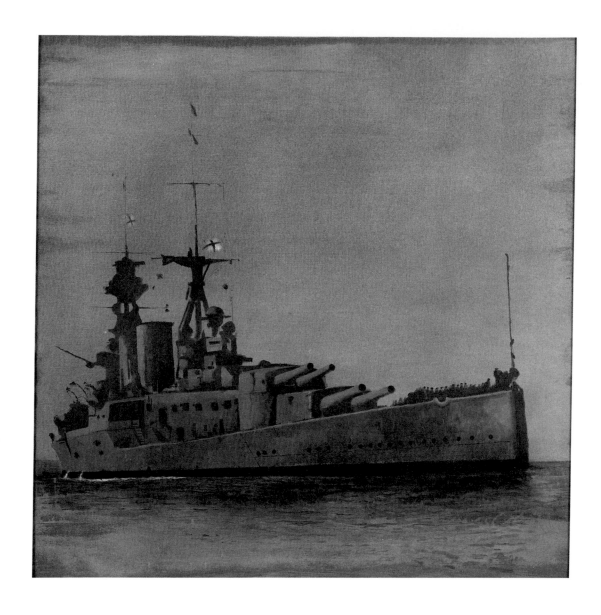

8
HMS Hood, Foe, 1965

9
HMS Hood, Friend, 1965

6
French Navy, 1964

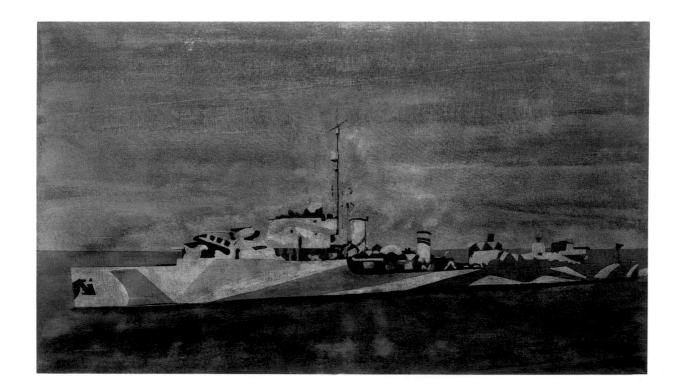

10
Night Rider, 1965

1965 — 1970

'I like the light of Corot'[10]

Morley's idea of colour, he once said, derives from the decoration of the Coronation mug given to every schoolchild when George VI came to the throne in May 1937 (fig. 6).[11] Each pottery produced its own design, but royal commemorative souvenirs with their cheap transfer printed designs obey the same principles of colour. The obligatory red, blue and gold stand out against the white of the china with a bold heraldic splendour. This early experience of colour is as crucial to the paintings Morley began in 1965 (which he later called 'Superrealist') as the 'dreadnought look' had been to the works that had preceded them.

On a visit to Morley's studio in 1965, Richard Artschwager had seen an abstract painting with four small vertical panels representing a cruise ship suspended from the lower edge of the canvas. He advised Morley to abandon the abstract painting and hang on to the panels (fig. 7). Another piece of advice was to go out and paint the cruise ships docked at Pier 57 within a short distance of Morley's studio. Morley followed Artschwager's advice, but when it came to painting a cruise ship he found himself overwhelmed by the difficulty of registering the mass of a huge vessel in one go ('one end is over there, the other end is over there, a 360 degree impossibility'). He gave up the idea of painting a ship from life, walked into a nearby shipping office and bought a postcard.

With a few exceptions, the sources for Morley's imagery are small and compact illustrations – photographs, postcards, calendars, brochures, model kits of airplanes – the sort of thing that can be casually picked up, looked at and as casually discarded. In some mysterious way, this intimacy with the hand-held image is preserved in the hugely magnified scale of the finished work, but how or why this should be so is hard to define. It may have something to do with Morley's preference for those images that pack information into a small space in the most economical way, or the way the grid encourages attention to detail so that the illusion of smallness is built into the way we see. Or, it may have to do with the intimacy that is woven into the fabric of the painting through the thousands of minute contacts between the brush and the canvas. *SS Amsterdam in front of Rotterdam*, 1966 (cat. 13), one of the most hallucinatory of the Superrealist paintings, is painted with a grid so small

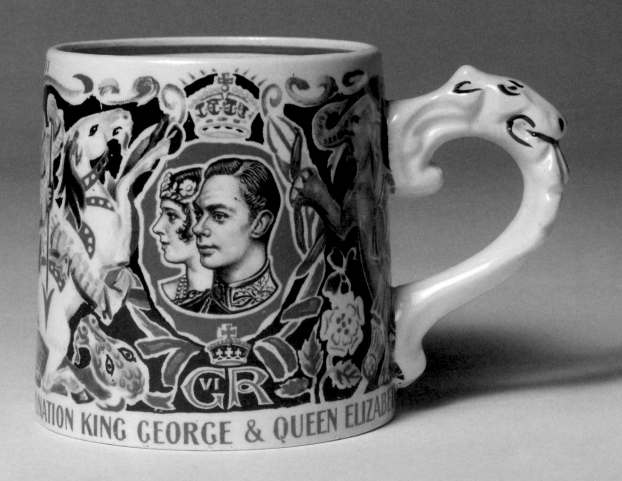

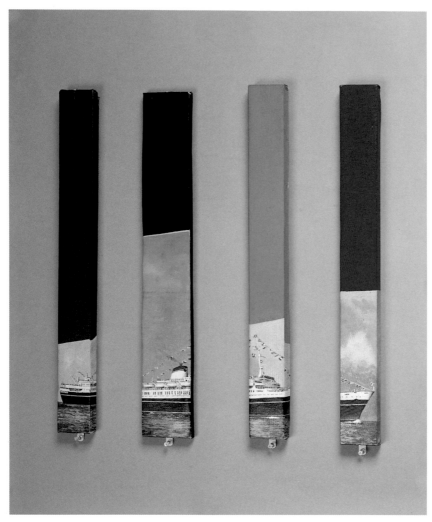

fig. 7
Malcolm Morley
*Cristoforo Colombo: Bow, Bridge,
Smokestack, Stern,* 1965

that each square had to be painted with the aid of a magnifying glass. This technique
(in effect the technique of the miniaturist), allowed Morley to consider each unit of the
grid as a tiny self-contained abstraction. (Then, as now, he often works with the canvas
upside-down or on its side so that the natural up and down rhythm of the brushstroke is
interrupted, or, as Morley puts it, 'a downbeat becomes an upbeat'.) Morley has always
gone for the kind of process that, as he says, 'cuts down or disallows certain things to
occur, such as Mondrian's never allowing a curve, or Cézanne's diagonal brushstrokes'.
The grid imposes the necessary strictures but it also functions, the artist tells us, as 'a
container of emotion', a phrase that can be read two ways.

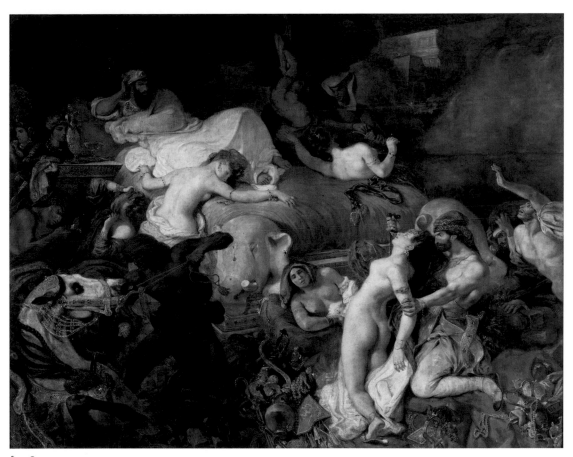

fig. 8
Eugène Delacroix, *The Death of Sardanapalus*, 1827

A great deal of the emotion in the Superrealist paintings comes from Morley's relation-
ship to art. He often speaks about the artists of the past in the affectionate terms reserved
for close friends. Malevich is a favourite (cat. 51), Mondrian another (cat. 39), while
Cézanne is spoken of as a teacher, morally as much as artistically. Morley's allegiance to
his profession is overtly made in the one Superrealist painting that is a faithful reproduction
of another work of art. With *Vermeer: Portrait of the Artist in his Studio*, 1968 (cat. 17),
Morley takes fidelity to the limits, for he is not just copying a celebrated masterpiece
(Vermeer's *The Art of Painting*, c. 1666 – 68) but making it a monument to painting itself.
Its qualities are those he holds most sacred and which he has best described in relation
to another masterpiece, Delacroix's *The Death of Sardanapalus* (fig. 8). 'It is like a sheet of

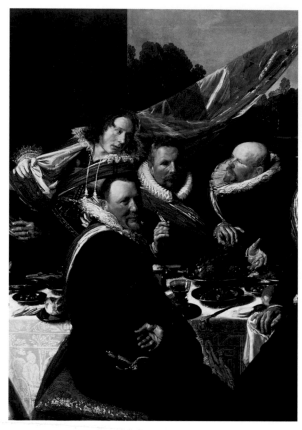

fig. 9
Frans Hals
*Banquet of the Officers of the St. George
Civic Guard,* 1616 (detail)

plate glass. It's solid, and it has substance and thickness, but it also has an even surface. And, for me, that's the highest aesthetic quality in painting.'[12]

When Lawrence Alloway compared the immaculate blues of Morley's Superrealist skies to the 'clear hard light of Corot's Roman landscapes', he was picking up on the old master quality of these paintings.[13] Others have been struck by Morley's affinity with the art of the past. In 1989, David Sylvester likened the exuberance of Morley's recent paintings to a Mardi Gras revel by Frans Hals.[14] *Ship's Dinner Party*, 1966 (cat. 12), a magnificently orchestrated figure composition, displays a different sort of exuberance, the flashy confidence that comes with wealth and status. Again, Hals comes to mind. His civic banquet (fig. 9), like Morley's dinner party, is a highly polished social performance. In both paintings there is the sense that the spectacle is being played out in front of us and for our benefit. Furthermore, the two painters share a taste for the audacious stroke. The woman entering from the left in cat. 12, her size distorted by the camera and her

fig. 10
still from *Alexander Nevsky*, 1938

appearance bleached by its flash, is as daring an intervention as the furled thrust of Hals's richly emblazoned standard.

The artist who counted most of all, though, was Cézanne. His paintings had been Morley's first contact with art when he was a student at Camberwell and he counted because the Superrealist paintings are, amongst other things, an affirmation of Cézanne's painterly intelligence. They are also an assault on a certain kind of thinking prevalent in New York at that time. Morley felt strongly that Clement Greenberg, a powerful and vocal critic, was betraying Cézanne by his insistence that painters should throw out illusionism and paint so flat and so abstract that pigment became a part of the canvas weave, leaving no room for ambiguity. 'Cézanne', says Morley, 'would have been horrified by this idea because he believed just the opposite – that it [the picture plane] cannot be three-dimensional enough.' And he goes on, 'Paradoxically, the more you flatten it, the more illusion you

fig. 11
Jasper Johns
Souvenir, 1964

get. But only a certain kind of sensitivity or intelligence – the painterly intelligence – can understand that. It is very hard to keep both the illusion and the plane simultaneously … this was the incredible genius of Cézanne'.[15]

Coronation and Beach Scene, 1968 (cat. 16), the most condensed and tightly packed of all the Superrealist pictures, is a prime example of the painterly intelligence Morley describes. The large white border brings pressure to bear on the recessive space of the illusionistic image in the middle by flattening it still further so that it stands out in the way a heraldic device stands out on a banner or a shield (fig. 10). Or, given its celebratory mix of red, blue and yellow, the way a transfer-print stands out on a piece of china (fig. 6). Another reason why Morley was attracted to the two images (which he found in the same Dutch travel brochure) was the intricacy of their graphic detail which he found so mesmerizing that he didn't mind which way up they were seen. 'From the painterly point of view you could look at them upside down.'

Sly references to living artists are another dimension of what Morley calls 'the rich brew' of his imagery. Take the stripes of the deck-chairs in cat. 16, which may or may not be allusions to the glowing chromatic stripes of the colour field painter Morris Louis, or the smooth parallel bands of sea and sky that divide the two tourist attractions with the finality of a Barnett Newman stripe. Even the colours seem to take up a New York refrain. 'Red', 'Blue' and 'Yellow' are words that Jasper Johns used in his paintings of the 1960s as a sort of mantra (fig. 11) while Roy Lichtenstein's use of the three primary colours raised printers' inks to a new aesthetic high.

The aesthetic high of these Morley paintings comes from the intensity of the light, from the perfection of brightness and from the way brightness bestows perfection on everything it touches. Perfection is built into Morley's highly exacting process. Colour is applied in a process he has described as tiptoeing over the surface 'without causing a ripple'.[16] He takes pleasure in making the painting process as elegant as possible. His actions are careful and unhurried. Sharpening a pencil, he says, 'should be done aesthetically'.[17] Even coaxing the paint out of the brushes at the end of the day is an art in itself. 'Everything takes time. Basically that's the space we are in.'

Perfection is built into his choice of subjects, but the staged pleasure universally demanded by advertising brings with it a powerful undertow of melancholy. The perfect family (cat. 15), the perfect cruise (cat. 13), the perfect dinner party (cat. 12), are as illusory as the plot of a Barbara Cartland novel. When Morley happened to see a collection of romantic novels being offered for sale to raise money for his local health clinic, his first thought as he looked at the shiny embossed covers laid out on the table was 'this would make a terrific painting'. At the same time, he was very conscious of the audience for these cheap illusions, conscious of 'observing another species that happens to be the majority'. There is, he says, 'a certain irony in going to a source that is not able to notice itself', a comment that embraces the Superrealist imagery as a whole. Morley's ocean liners, as Michael Compton pointed out in 1983, 'symbolise an ordered and protected shell against the wild environment of the sea. They are going somewhere or arriving.'.[18] Romantic novels are another form of protective shell. Like the brochures (fig. 12) and the calendars with their seductive messages of leisure, security and a life of unruffled calm, books such as *Sweet Knight Times* and *Memories of Love* bring the unobtainable a little closer. It should be no surprise that Morley, who had lived through the bleakness and deprivations of wartime London, and who had spent several years of his youth in the

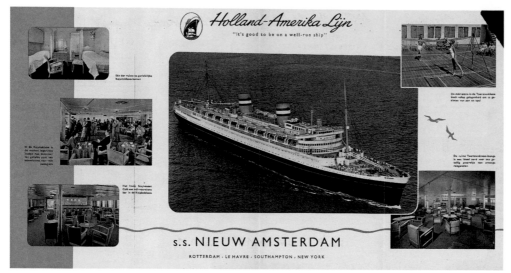

fig. 12
Holland-Amerika Lijn brochure, 1955

cheerless surroundings of Borstal and prison, might well be attracted to images that play on the promise of the good life. This train of thought takes us back to the importance of colour. 'Colour is such an emotional thing', Morley told David Sylvester, 'one of Piaget's tests on children's perception of colour showed that children whose parents were divorced saw less colour. They literally saw things greyer, and children who came from a happy family literally perceived colour as being brighter. And I remember myself seeing the world grey. I could not see colour in the world for many years as a young painter.'[19]

The Superrealist paintings came to an abrupt end in 1970 with *Race Track* (cat. 18). Morley put the final touch to this painting after seeing the Costa-Gavras film *Z* (a tough political commentary on recent events in Greece). Within minutes of leaving the cinema he had decided to 'cancel' out his latest painting. Back in the studio, he began rehearsing giant Xs on sheets of plastic. 'I just didn't want to go and splash it on, you know, but really consider it. And the X got thinner and thinner because although I wanted to do this, I really didn't want to destroy the painting. And so I got to the finest X you can imagine and then we reversed the sheet and printed it on the surface of the painting. And lo and behold! It was Malcolm's X on a race track in South Africa.'

The political significance of linking the name Malcolm with the letter X only hit him later. For the moment, it was enough that the Superrealist phase had been cancelled.

12
Ship's Dinner Party, 1966

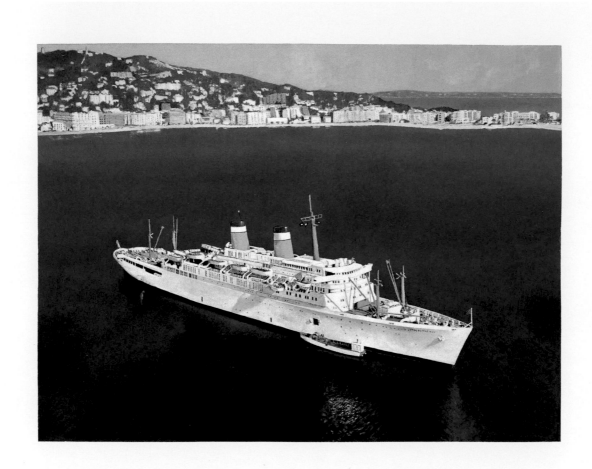

11
SS Independence with Côte d'Azur, 1965

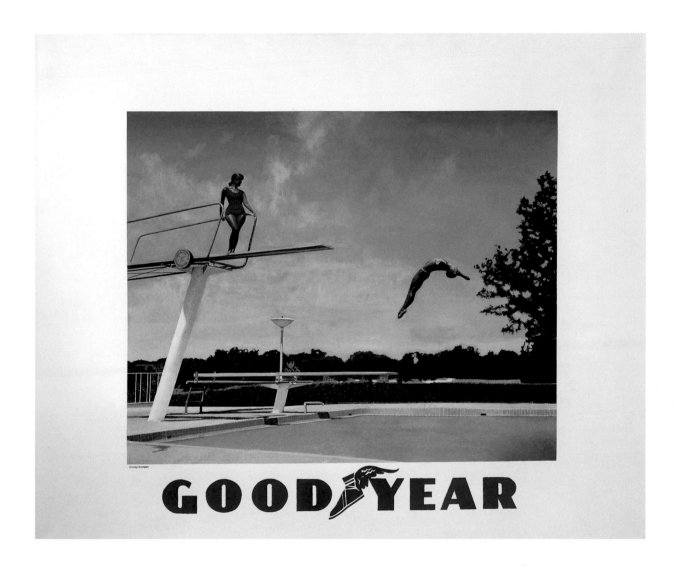

14
Diving Champion, 1967

13
SS Amsterdam in front of Rotterdam, 1966

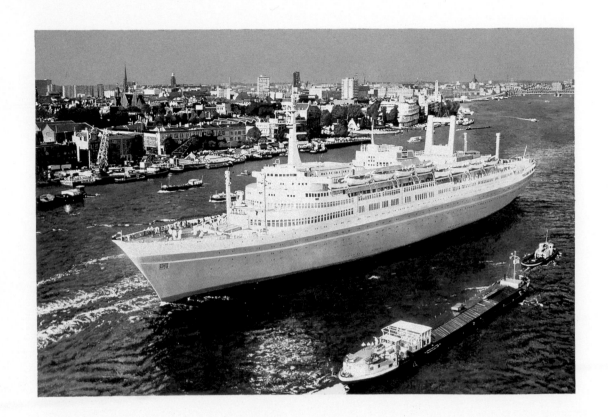

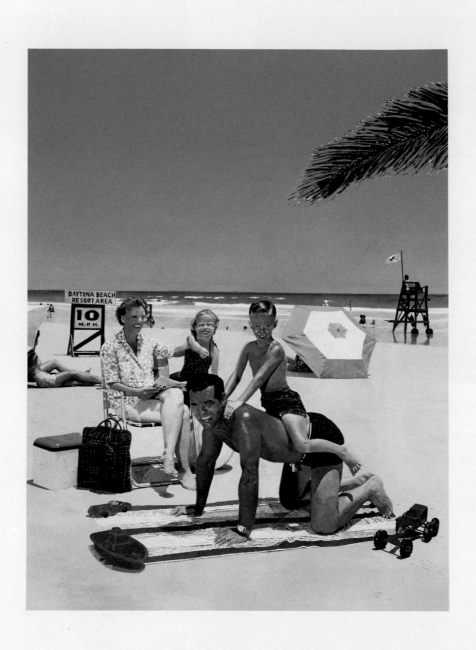

15
Beach Scene, 1968

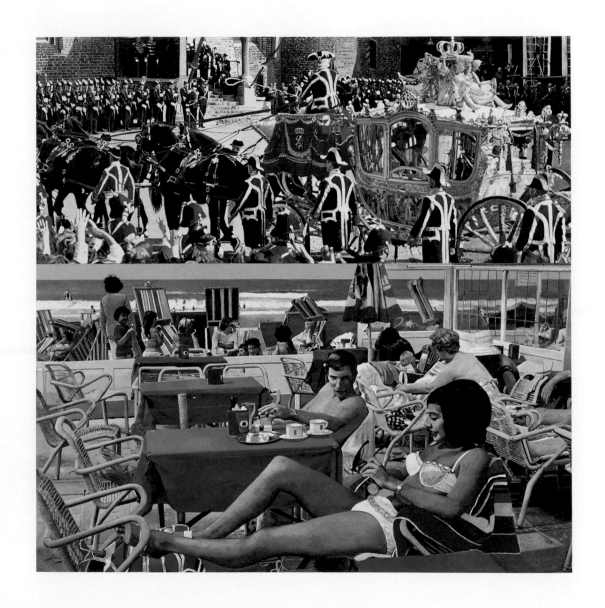

16
Coronation and Beach Scene, 1968

17
Vermeer: Portrait of the Artist in his Studio, 1968

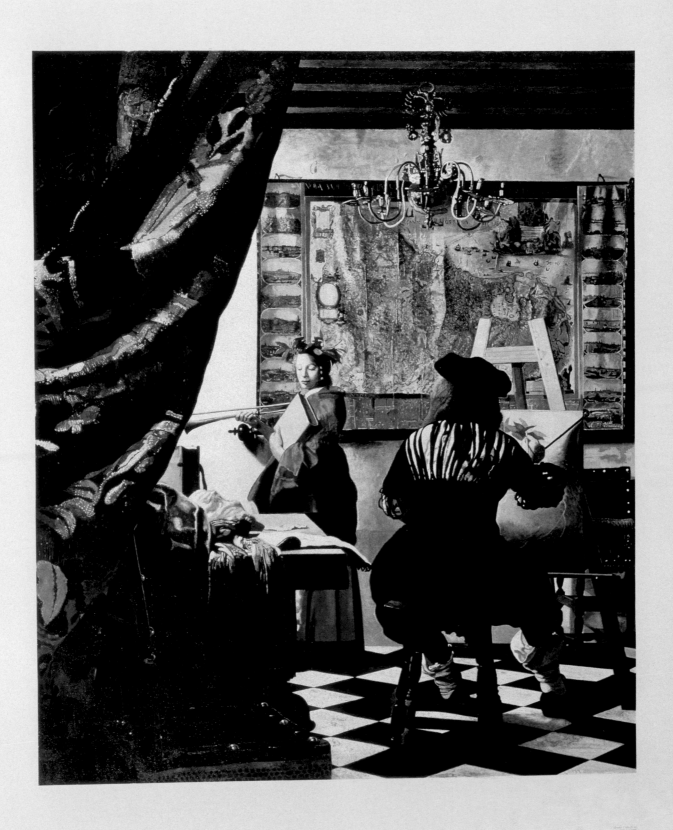

18
Race Track, 1970

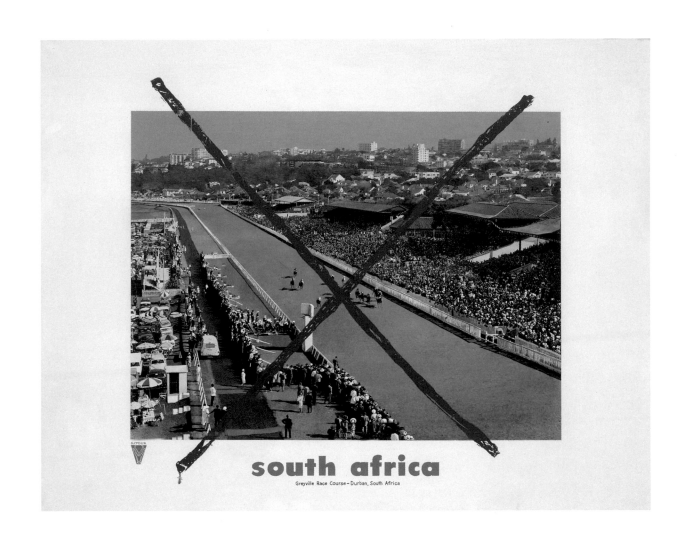

south africa

Greyville Race Course – Durban, South Africa

'There isn't one process. It goes through the meat grinder and out comes this chopped meat. You can change the setting for rough or smooth surface, but it comes through a sort of digestive system.'

X-ing out *Race Track*, 1970 (cat. 18) was not an impulsive act. The urgency that had inspired the gesture was tempered by the precision needed to carry it out. The tension that comes from pulling in opposite directions is characteristic of Morley and it is therefore entirely appropriate, if almost certainly unconscious, that the title of *Safety is Your Business*, 1971 (cat. 22) delivers an urgent message about caution. Morley began this painting in acrylic but half-way through impatiently switched to oils (the transition occurs roughly half-way down the canvas). He had, he said, taken acrylic as far as he could and now couldn't wait to finish the painting before making the switch. The wetter medium of oils allowed more variety of texture because it could be modulated in a way that acrylic resisted. Morley was tiring of the time-consuming technique demanded by the Superrealist paintings (one canvas could take as long as six months to complete). He wanted to paint faster and he wanted the surface to register rather than to absorb the brush marks. The surface of *Safety is Your Business* has a slightly abrasive quality suggestive of city dirt and grit. Details such as the line of windows picked out with sharp scratchy lines, the dry prickly feel of the vegetation and the weathered unevenness of the brick wall chafe rather than soothe the eye. The surface of *Goodyear*, 1971 (cat. 19), on the other hand, has the ruffled look of water disturbed by a breeze. The beach is seen from a distance and in the loose generalities of the holiday brochure. Morley's new way of painting demanded a looser sort of image.

As it turned out, Morley was not finished with acrylic. *School of Athens*, 1972 (cat. 23) began as a performance piece. Morley had been asked to give a lecture at the State University at Potsdam in New York but chose instead to paint a copy of Raphael's fresco

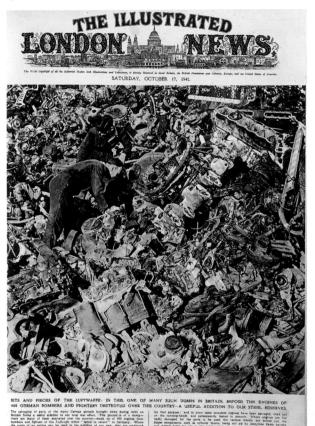

fig. 13
The Illustrated London News, 17 October 1942

The School of Athens in front of an audience. A canvas was duly prepared for him by the University, and Morley, dressed as one of Raphael's figures (Pythagoras), began his performance accompanied by a piece of music (variously remembered as Scriabin, Monteverdi and Scarlatti). In the process, something went wrong. When the canvas was sent back to him, Morley saw that he had misread the positioning of the grid by one square with the result that everything in the one row he had completed (at the centre of the painting) had shifted to the right. As a painter who likes to use mistakes 'for creating a sort of counterpoint', he immediately welcomed the error and incorporated it into the weave of the finished work. Error, after all, is another way of countering perfection.

Nor was he finished with the postcard. There are two versions of *New York City Postcard* of which cat. 21 is the first. (The second version is over eight metres in length, free standing and double-sided. It is a floor piece and dedicated to the sculptor John Chamberlain).

The version shown here is nearly six metres in length. It was commissioned by the recipient of the original fold-out postcard which Morley had mailed to them and they had mailed back. The painting is a marvellously sustained orchestration of tone, working from dark to light, from the shadowy blacks and browns at one end towards the triumphant red, white and blue at the other. The two airmail stickers and the stamp are pieces of collage made of coarse canvas cut with pinking shears, a detail that makes one think of the stars on a Jasper Johns flag. The unusual technique of acrylic mixed with wax – not unlike the encaustic technique adopted by Johns – seems to be another form of tribute. The uneven, granular surface of Morley's painting is also an evocation of the abrasive textures of the city.

In *New York City Postcard*, 1971, Morley was painting the city bit by bit. In *Untitled Souvenirs, Europe*, 1973 (cat. 24), he was 'painting the world bit by bit'.[20] And, for the first time since 1964, he was painting without the structure of the grid (even though the shapes of the snapshots, postcards and guidebook illustrations hang together in a wild parody of a squared-up image). The painting shows the artist naked and seen from above trampling on the social column of a Mexican newspaper. 'By recycling garbage into art. Everything is useful, everything is a fit subject for art.'[21] And, as he went on to prove, art itself can always be recycled.

The shuddering rent down the middle of the telephone book in *Los Angeles Yellow Pages*, 1971 (cat. 20) can be read as an allusion to a Newman 'zip', a reading permitted by another 'homage', the two incomplete red arcs which, as Morley has confirmed, refer to the target paintings of Jasper Johns. The recyling goes on. *SS Amsterdam in front of Rotterdam*, 1966 (cat. 13) reappears in *Age of Catastrophe*, 1976 (cat. 27), its imperturbable calm shattered by disaster. That image of catastrophe is packed with incidents and portents (the submarine and dead bird suspended in front of the scene could have come straight out of one of Robert Rauschenberg's combine paintings), but the painting has a wider meaning. 'I feel that Barney Newman emptied space and I'm filling it up again', Morley had told an interviewer a few years earlier.[22] And sure enough, in *Age of Catastrophe* a hideous disaster lands like a meteorite on the white surface of a Newman painting, spreading its debris. At the same time, this collision between figuration and abstraction reveals the metaphysical bond uniting the two painters. 'All life is full of terror', Newman had written in 1946,[23] and his world, seemingly without incident, is no less stark in its message, for it allows us to share the dread of standing 'at the very extremity of the boundary beyond which there is nothing'.[24]

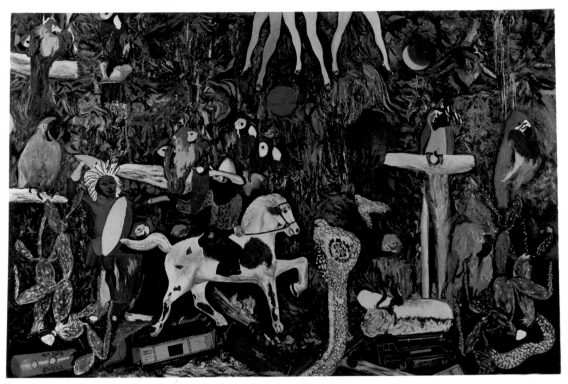

fig. 14
Malcolm Morley
Christmas Tree – The Lonely Ranger Lost in the Jungle of Erotic Desires, 1979

The violence of these paintings reaches its climax in *The Day of the Locust*, 1977 (cat. 28). The title is taken from Nathaniel West's 1933 novel about Hollywood in which the artist-hero, Tod Hackett, is working on a catastrophe painting of his own. 'The Burning of Los Angeles', a huge canvas, steadily grows into a panoramic vision of increasing violence and incongruity. In the final chapter, Hackett is caught up in a mob and in his delirium imagines himself finishing his masterpiece, working 'at the flames in an upper corner of the canvas, modeling the tongues of fire so that they licked even more avidly at a corinthinian column that held up the palm leaf roof of a nutburger stand.' The disconnected imagery of the daydream has become entangled with the props of a Hollywood set. The props in Morley's painting share this crazed randomness. Instead of discarded scenery he uses models and toys: an Eskimo, a Red Indian, a horse, a cut-out doll and a collection of toy soldiers, bayonets drawn, battling it out below. Los Angeles in an earthquake has become London in the Blitz, buildings collapsing, fires raging, sirens

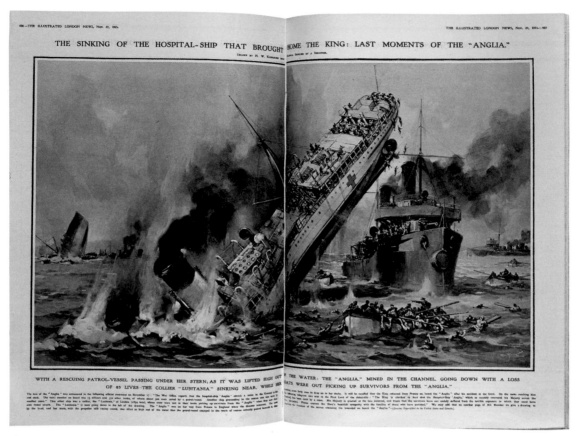

fig. 15
The Illustrated London News, 27 November 1915

screaming. Morley has likened the appearance of the paint to the shrapnel and other debris that rained down from the skies during the air raids and which was, he says, 'often ornamental, shaped and textured by the force of the explosion.' (fig. 13).[25] West's novel ends with the artist-hero lying injured in an ambulance, imitating the high-pitched scream of its siren.[26] That scream can be related to Morley's own state of mind during this period in which bouts of extreme anxiety combined with bouts of artificially-induced highs provoked hallucinatory moments that bordered, the artist has said, on insanity.

The violence, including the conceptual violence done to his own paintings, would be more disturbing if it were not tempered by the unthreatening scale of the postcard and the children's toys which act as shock absorbers. Childhood itself can be an effective shock absorber. In *Christmas Tree – The Lonely Ranger Lost in the Jungle of Erotic Desires*, 1979 (fig. 14),

the masked horseman makes his getaway, not with a gun, but with a rubber dildo. This image, delicately balanced between the virile and the impotent, masks the terrors of adulthood with a flash of schoolboy impudence. Morley remembers that as an adolescent in the Blitz he didn't have 'the real feeling of horror that the adults had... . I had this weird kind of appreciation of the dogfights over London.'[27] Yet the violence is undeniable. A comparison with Warhol's images of violent death (the Death and Disaster series begun in 1962) needs to be made even in the knowledge that Morley's appetite for disaster had been formed years before when, as a child, he buried himself in the pages of *The Illustrated London News* (fig. 15). But the comparison is useful nonetheless. Warhol's disasters differ profoundly from Morley's in that they are seen through the eyes of an adult. Morley's are seen through the eyes of a child. And they are the more violent for it. The actions played out in the catastrophe paintings – smashing, ripping, stamping, stabbing – suggest an anger and frustration that is far removed from Warhol's coolly composed elegies.

19
Goodyear, 1971

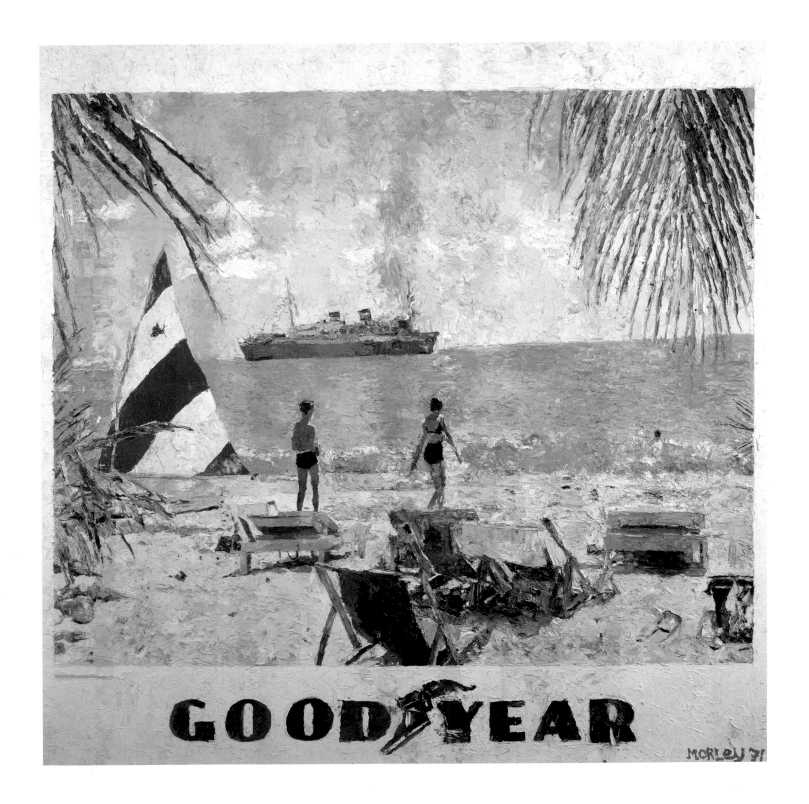

22
Safety is Your Business, 1971

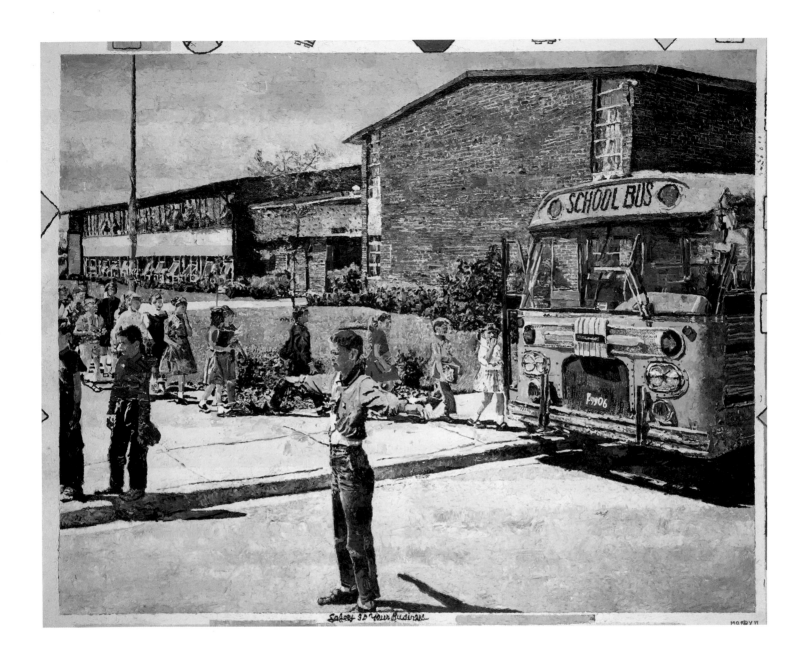

21
New York City Postcard, 1971

20
Los Angeles Yellow Pages, 1971

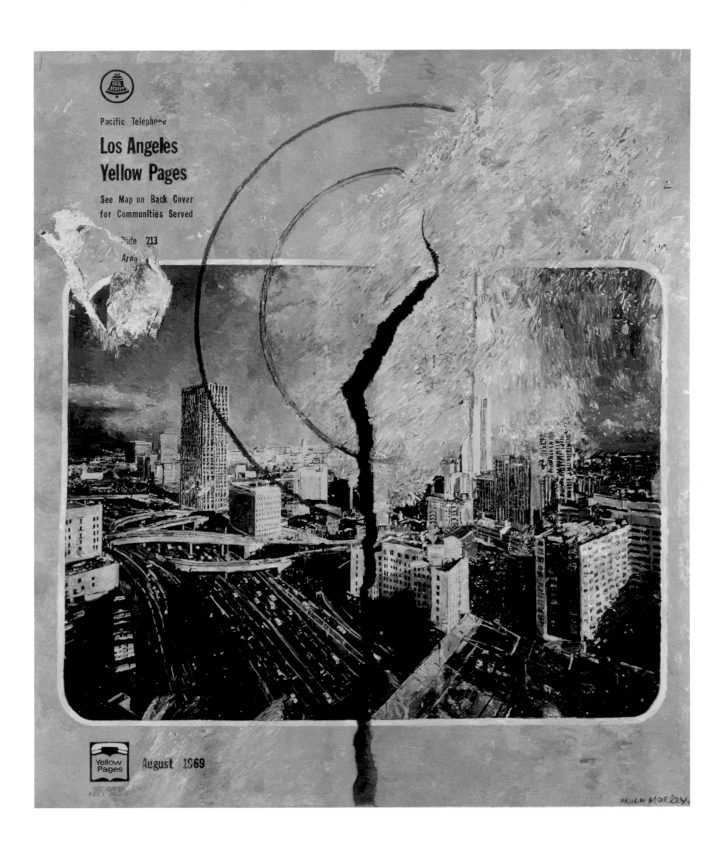

23
School of Athens, 1972

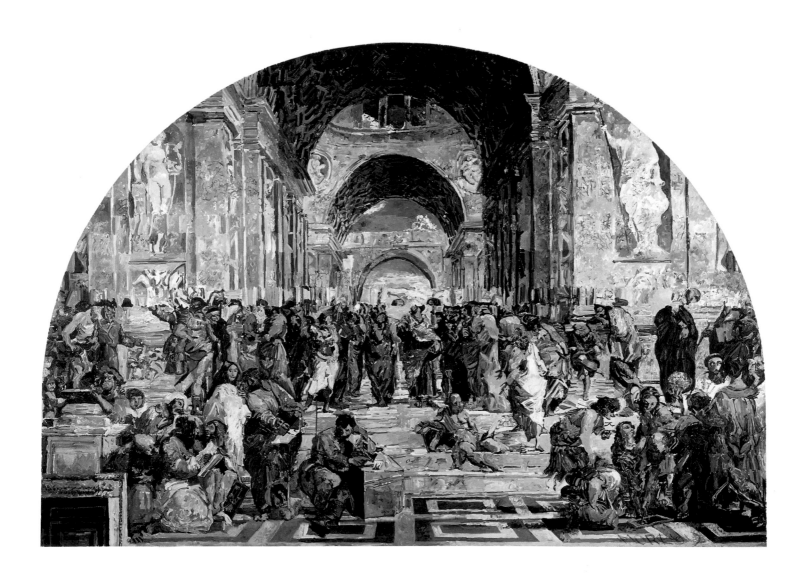

24
Untitled Souvenirs, Europe, 1973

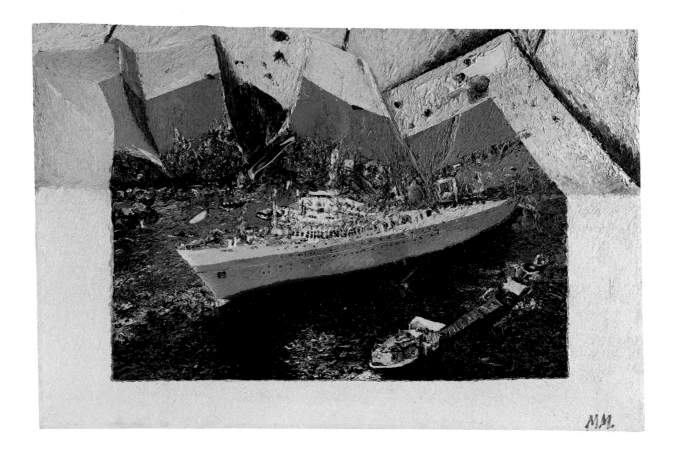

25
Disaster, 1974

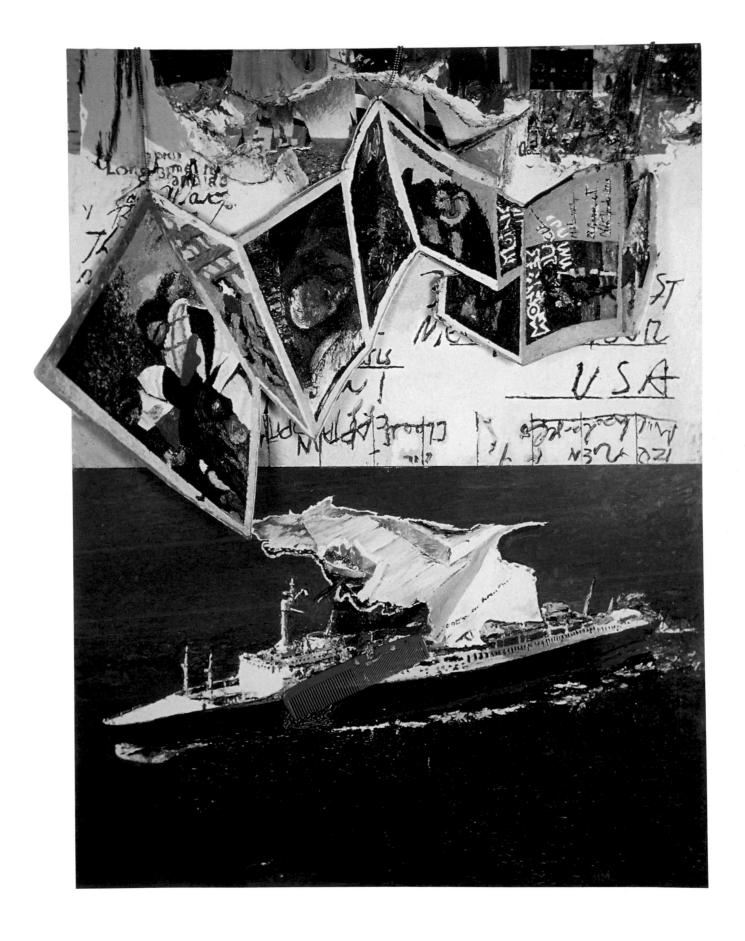

26
SS France, 1974

27
Age of Catastrophe, 1976

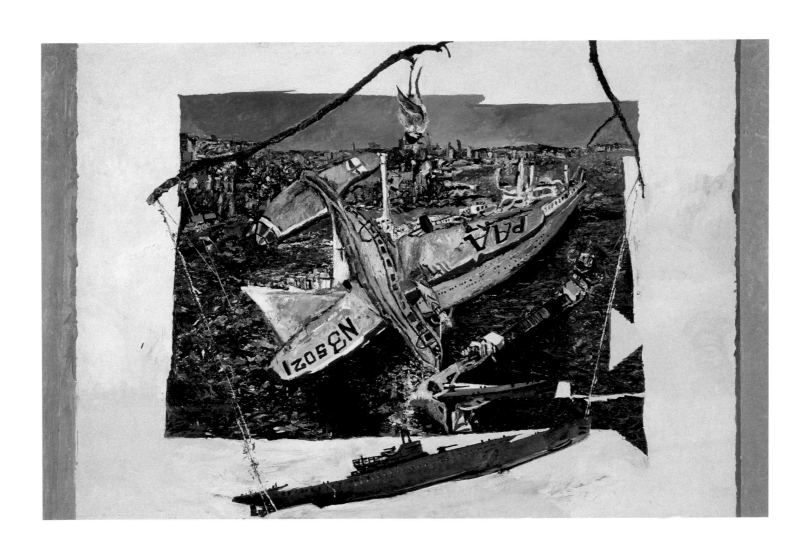

28
The Day of the Locust, 1977

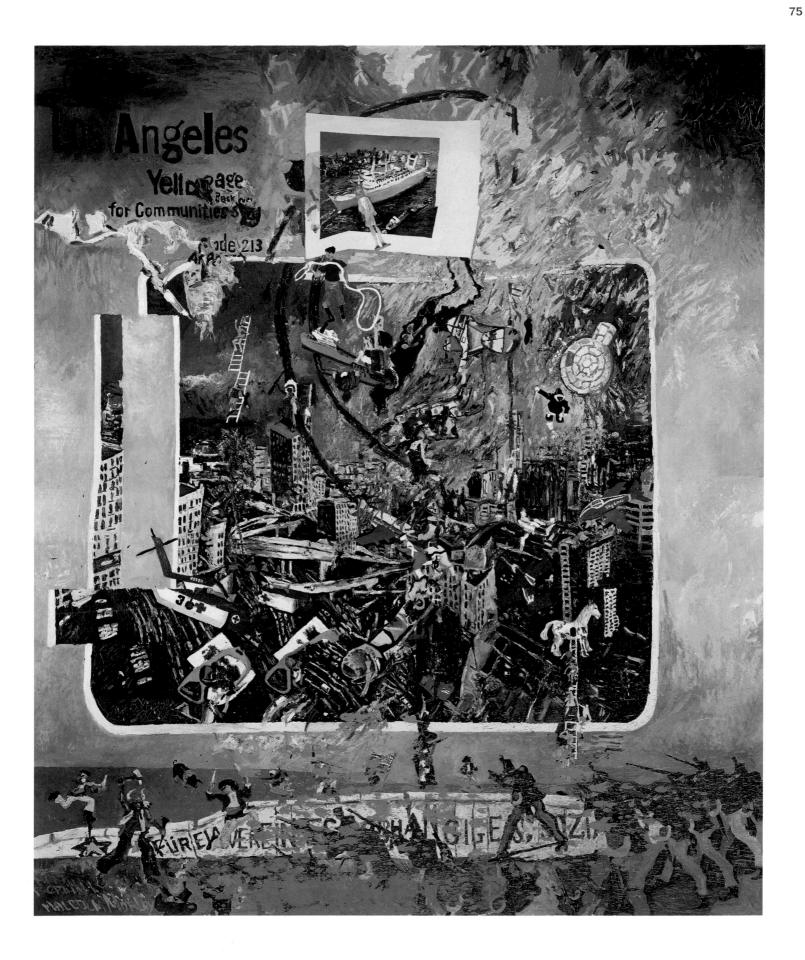

29
Out Dark Spot, 1978

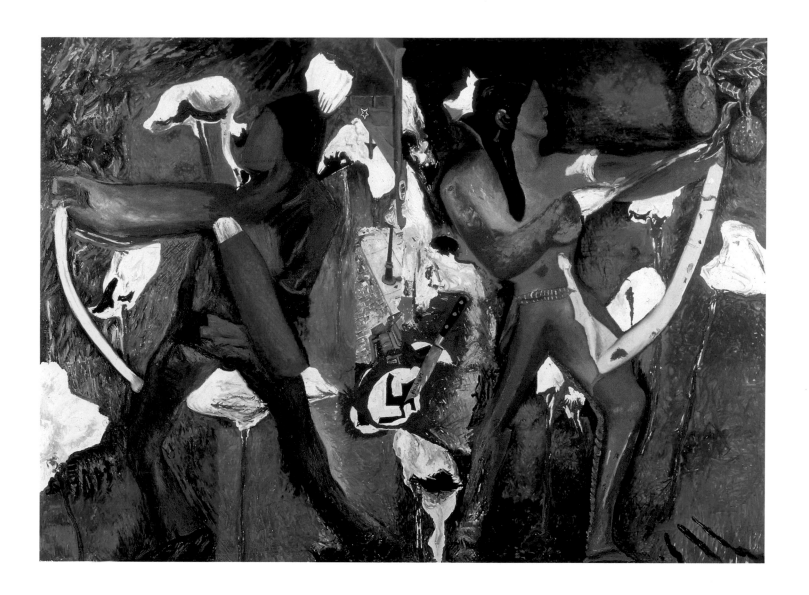

30
The Day of the Locust III, 1979

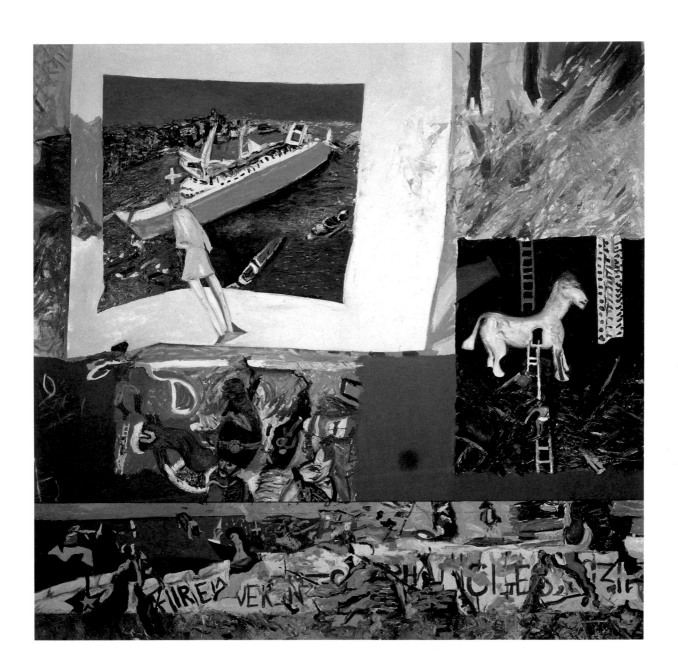

'I want the eyes to float and bob like buoys on the wetness of the painted surface.'[28]

The catastrophe paintings deal with helplessness in the face of unpredictable disaster. The paintings of the 1980s, no less awesome in content, leave behind the shock of the newspaper headline and plunge into myth. They are like scenes chosen at random from the great epics. *Aegean Crime*, 1987 (cat. 35) is thick with spilt blood; toy soldiers drum their way out of the shadows of giants in *Night on Bald Mountain*, 1987 (cat. 36), while a horse with its helmet mount picks its way over a beach on which a modern Helen is sunbathing naked (cat. 32). Two ceremonially clad figures lope across the fiery desert of *Arizonac*, 1981 (cat. 31) as though bound for some shrine on which to place the offerings they hold in their hands. These figures, based on the same souvenir Kachina doll seen in cat. 36, appear again in *The Injuns are Cuming – The Officer of the Imperial Guard is Fleeing*, 1983 (cat. 33). On the left of this painting, the two 'injuns' advance fearlessly, putting to flight 'the imperial guard' – a streaky memory of Géricault's equestrian hero (fig. 16). It's as though primitivism has sent history painting packing, for the costumed dolls can be seen as metaphors for the tribal masks and fetish objects through which Picasso expressed the sorts of terrors that are beyond naming.

While Morley's mythologies provoke comparisons with the triptychs of Max Beckmann and the bulls and minotaures of Picasso, their agitation and intensity have more in common with the savage, dark, totemic works painted by Jackson Pollock in the early 1940s. Beckmann's symbolism is there to be deciphered, but the symbols and codes of a painting such as Pollock's *Guardians of the Secret*, 1943 (fig. 17) are not. The power of his imagery lies in its brooding secrecy. The same is true of *Aegean Crime*. Even though we can recognize the scenes and characters – a French Romanesque figure of Christ, a reprise of a recent painting by Morley (*Day Fishing at Heraklion*, 1983), a Minoan head and a Roman copy of a bust of Alexander the Great – we cannot put them together to make a story. The only sense they make is as a terrifying conjunction of fears.

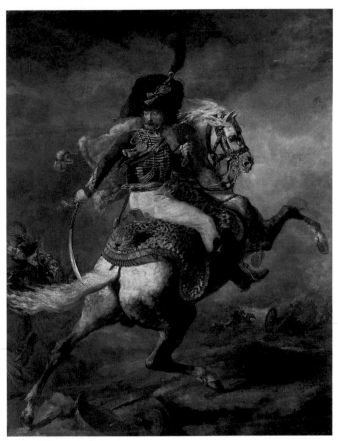

fig. 16
Théodore Géricault
*An Officer of the Imperial Horse
Guards Charging,* 1814

Morley's belief that his unconscious knows more than he does comes out of his intensive experience of psychoanalysis, which he recently described to Martin Gayford as 'the guts' of his whole life's work (see p. 125). Stuff thrown up in the psychoanalytical process can be used, he says, in the same way an artist uses jottings in a sketchbook.[29] As memories, insecurities and primitive emotions surface they are subsumed into images, or rather, into surges of agitation, ardour, terror. *Black Rainbow over Oedipus at Thebes*, 1988 (cat. 38), for instance, seems to deal with a childhood memory (recovered in analysis) of running up to a man seated on the seafront at Folkstone, tugging at his coat and entreating him to look at the sailboats. He hadn't noticed that the man was blind.[30] The sailboats that so delighted him and which he had tried in vain to show the blind man have been transformed into two brown sails, as high as mountains and as solid as slabs, which deny the view of the clear blue sky behind with terrible finality. The green stare of the figure

fig. 17
Jackson Pollock, *Guardians of the Secret*, 1943

in *Aegean Crime*, as remorseless as a power drill, is also about the deprivation of sight, an unsettling counterpoint to the shoal of mullet bobbing about in the waves like giant eyeballs. The Oedipus myth is linked in Morley's mind with Cézanne's famous observation that he felt as though his eyes were 'bleeding' when he tore them away from the object of their gaze. 'You can imagine the idea of the eyes sucking, like a suction pad', Morley told David Sylvester, 'I feel like that myself sometimes, that the eye sucks onto this and that it hurts to let go and move on to the next place.'[31]

These paintings are about the mind as theatre. The unpredictability of the plot, the scenery, the direction, are powerful stimulants for the imagination – almost frighteningly so – but as with all theatre the power of the drama depends on the power of the language. A book Morley often refers to in conversation is Norman O. Brown's hugely influential *Life against Death: The Psychoanalytical Meaning of History*, first published in 1959. In the chapter 'Language and Eros', Brown quotes from the writings of the Protestant mystic Jacob Boehme in which he laments the disappearance of what he calls the sensual language

fig. 18
Malcolm Morley
Macaws, Bengals, with Mullet, 1982

of the birds in the air and the beasts in the forest. 'Therefore man may reflect what he has been robbed of and what he has to recover in the second birth. For in the sensual language all spirits speak with each other, they need no other language, for it is the language of nature.[32] *Macaws, Bengals, with Mullet*, 1982 (fig 18), a painting Morley particularly cares about, seems to follows this passage to the letter. Birds, beasts and fish are as one, united by the wordless language of paint that is seen to be 'the sensual language all spirits speak with each other'. Like *Vermeer: Portrait of the Artist in his Studio*, 1968 (cat. 17), *Macaws* is an affirmation of the redemptive power of painting.

Navigating the churning emotions of his mythologies can be like navigating the swell of a heaving ocean, as ten seconds in front of *Seastroke*, 1986 (cat. 34) will confirm. The splashing, spattering, dripping and pouring takes Morley's language of paint to new extremes. Morley rejects a comparison with Pollock's drip painting, pointing out that he was much more interested in finding a way for oil paint to 'comment' on the behaviour of watercolour.[33] Watercolour had by now become indispensable to his way of working.

His travels to Greece and Crete, journeys that had inspired his embrace of mythology, had also inspired him to find a practical solution for continuing to paint while on the move. Many of the sources for these paintings are either watercolours or drawings. Made at different times and in different places, the watercolours allow a felicitous overlapping of images. The soaring rainbow in cat. 38, for example, brings back in another guise the brilliantly coloured arc of the Kachina doll's head-dress (cat. 33, 36).

Watercolour is a wet and risky medium and therefore ideally suited to an artist like Morley who likes to work with accident ('it gives a kind of primal quality'). The waywardness of watercolour acts as a stimulant not unlike the stimulus of emotions recovered in analysis. Les Levine, an artist and long-time friend of Morley's, has described the play between the oils and the free-flowing nature of watercolour and the way in which its unpredictability adds to the painting's imaginative strength. 'He's got all these things, such as the way a puddle dries that's been wet in watercolour, and the way the color will then dry in little rivulets and most beautiful forms will emerge that he calls oyster forms. It occurred organically, naturally in the watercolour. In the oil painting he's making a painting as an object. That puddle that was in the watercolour has now become a physical object in the oil painting, an image inside the image. It's a puddle of watercolour depicting an ocean but now it's been painted with oil paint. So he can fill in that puddleness and also the illusion of it simultaneously'.[34]

We are back in front of *Seastroke*.

31
Arizonac, 1981

32
Cradle of Civilization with American Woman, 1982

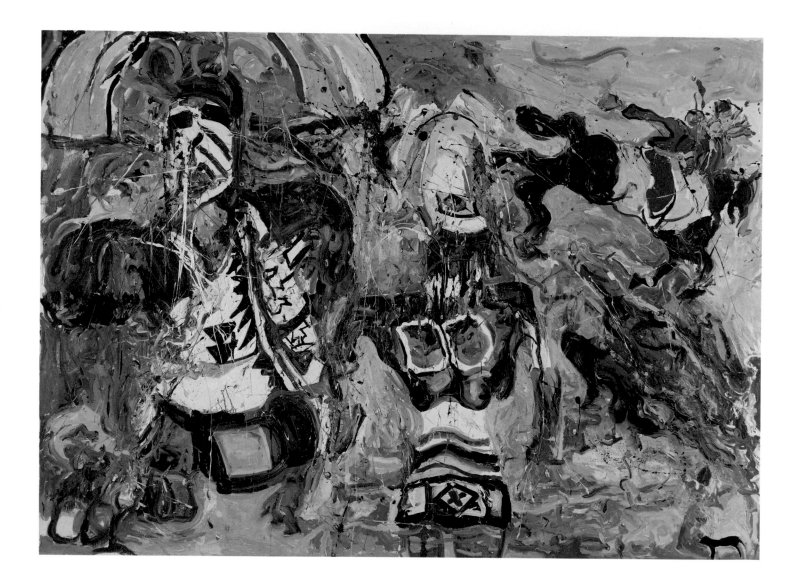

33
The Injuns are Cuming – The Officer of the Imperial Guard is Fleeing, 1983

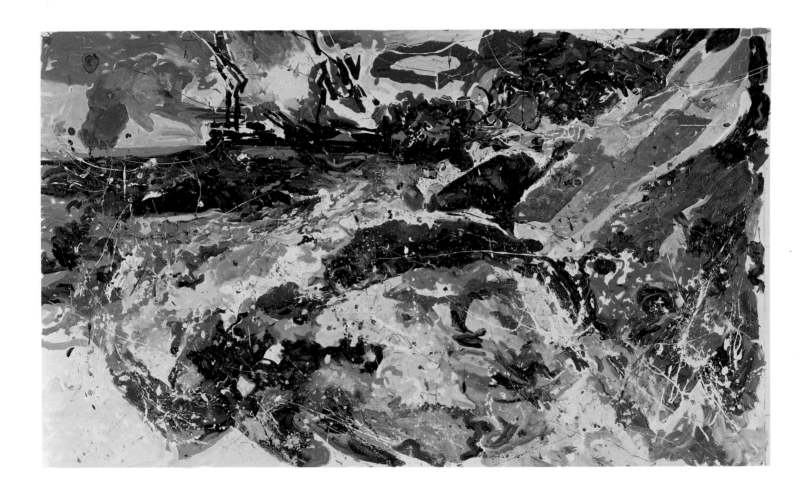

34
Seastroke, 1986

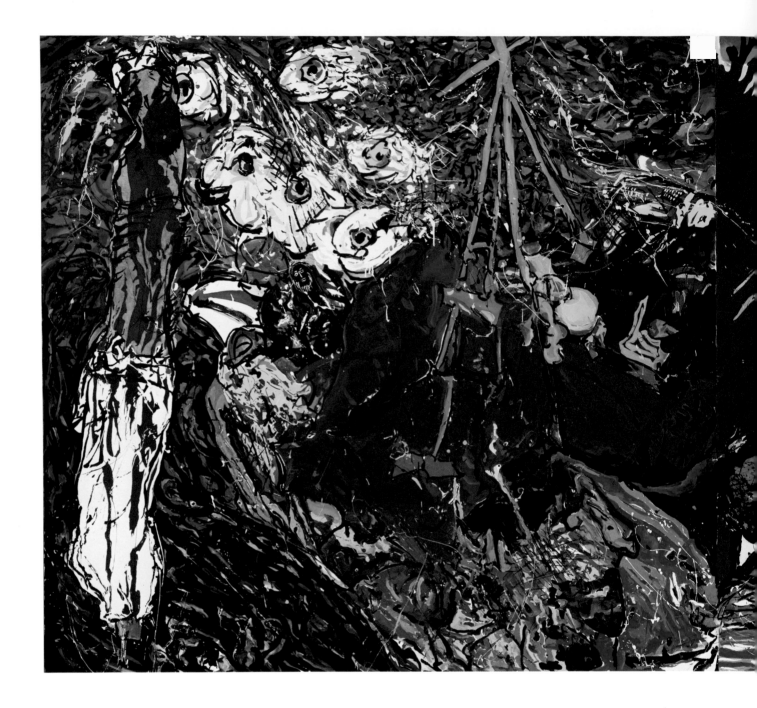

35
Aegean Crime, 1987

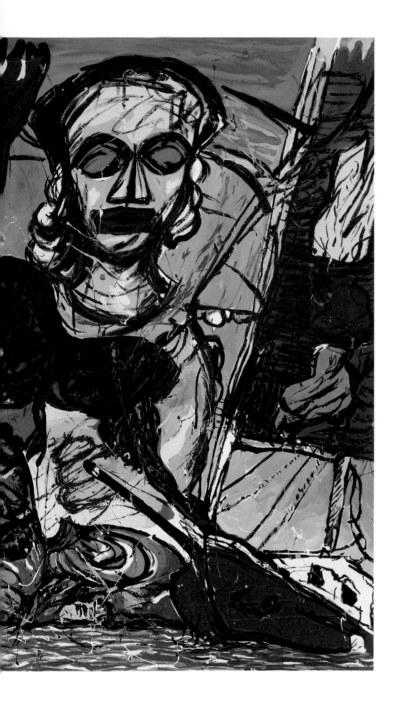

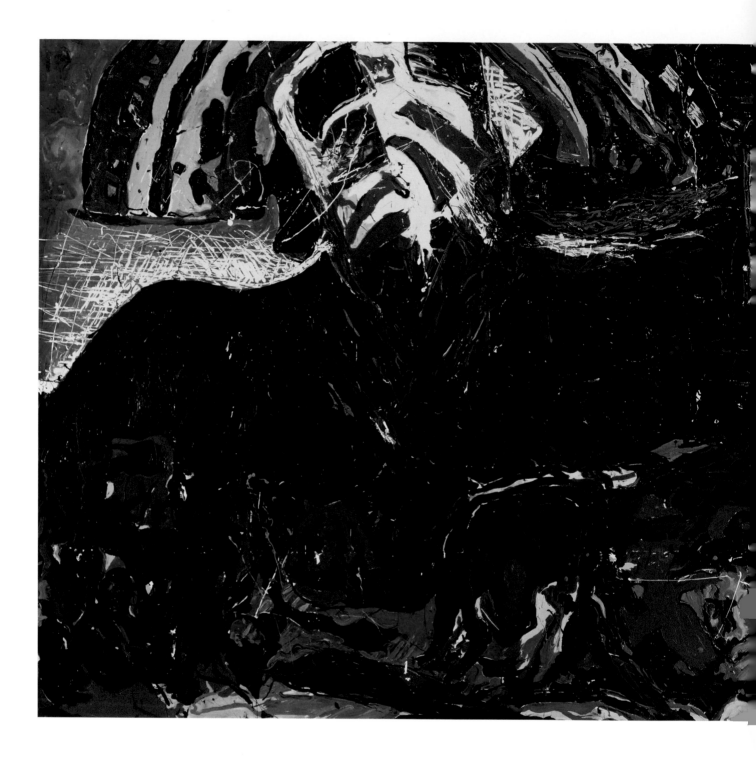

36
Night on Bald Mountain, 1987

37
Albatross, 1988

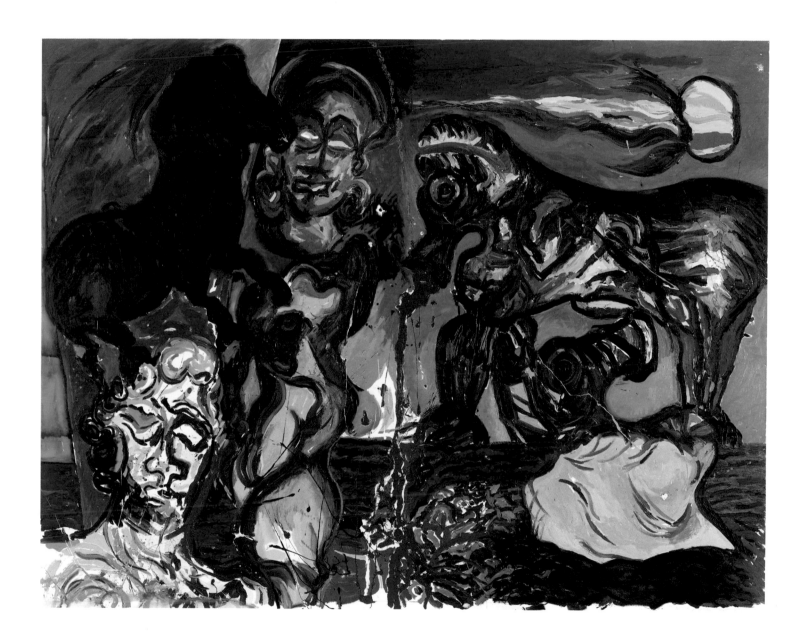

38
Black Rainbow over Oedipus at Thebes, 1988

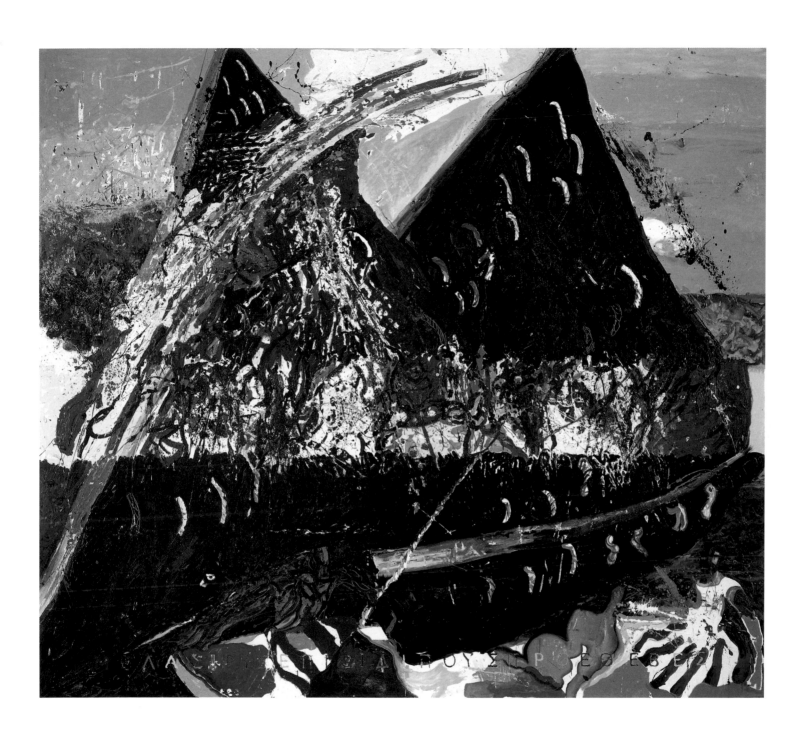

'It is much more difficult to make an abstract painting that is real than an abstract painting that is abstract.'[35]

Morley's love of the small-scale and the ready-made (postcards, calendars, posters, toy soldiers, etc.) can be traced back to the small balsa-wood model kits of his childhood. Making models has played a crucial role in his art over the past ten years, a development triggered by the recovered memory of a childhood catastrophe. One night, during an air raid, a newly completed model of a warship he had left on a window ledge was blasted to pieces by the force of an explosion near to the house where he was living. *The Flying Dutchman*, 1990 (cat. 40) shows the model, miraculously unharmed, resting on the window ledge in front of a ripped blackout curtain and jagged glass.

In Morley's latest paintings, safety usually wins out over danger. Lifeboats and lighthouses may topple and sink but they remain unscathed. Nowhere is this made plainer than in *Mariner*, 1998 (cat. 49), a grand scale 'combination' painting in which four separate paintings come together in elegantly choreographed collisions.[36] Ships, sailboats, bi-planes and galleons sail within a whisker of each other, keel over, crash into the ocean. Yet, the mayhem, rotating with the whirling nonchalance of a flying circus, is so carefully managed it is as though Prospero and Ariel are in league once more to make the boats and planes 'tight and yare and bravely rigged, as when / We first put out to sea.'. The tempests that raged in the paintings of the 1970s and '80s have been lulled by a painting process that goes back to the Superrealist years. 'It's all involved with the beauty of the surface now', Morley says, 'I'm not involved with what I had been in the past with all of those turbulent paintings. I probably won't make paintings like that again because there's no need for me to make them again … at some funny level this is always the approach to painting that I would have liked to have found.'

In rediscovering the models of his childhood, Morley seems to have rediscovered the pleasure he took in making them. A supremely crafted painting such as *SS Amsterdam in front of Rotterdam*, 1966 (cat. 13) was, he says now, an unconscious attempt to re-create

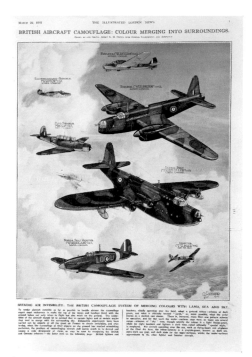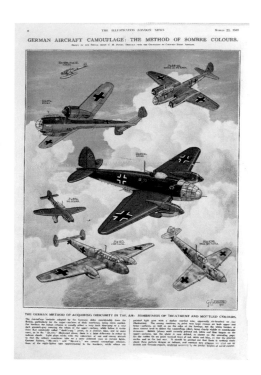

fig. 19
The Illustrated London News, 22 March 1941

that pleasure. His method then was more demanding but it was a method that allowed him to explore the process of painting. The same is true of recent works, but with the difference that Morley now paints as though allowing himself a special treat. One day recently, as he was mixing up some paint with a palette knife to get a certain quality of blue, he said: 'It's like Indian singing. They have sixty-four tones to an octave instead of eight and so I am mixing up quarter tones. I can go around all day thinking of this quarter tone of Egyptian violet and oh it's such a pleasure because you are not carrying the whole weight of it, so each part is valuable in itself, nothing is of lesser value. I'm involved with a romanticizing form of process. Why not?'.

Models and model kits are not the only things salvaged from childhood. As we have seen, Morley's visual education began with the pages of *The Illustrated London News*, a popular weekly dedicated to the latest and the most sensational in photo-journalism (a quick trawl through its pages shows the extraordinary breadth of images brought to the public each Saturday). The photographs impressed themselves so forcibly on his imagination that they seem to have formed a permanent mental picture library. A recent

fig. 20
Malcolm Morley, *Hollywood Film Stars and their Homes*, 1974

composition, *Messerschmitt with Spitfire*, 2000 (cat. 52), for example, is uncannily close to the detailed accounts of camouflage techniques employed by the Germans and the British during the Second World War which were reproduced in detail in one of the issues (fig. 19).

Models have also proved to be another way of keeping in touch with the artistic fraternity. In the mid 1970s he made a number of crushed aluminium sculptures (fig. 20) based on postcards of Hollywood film stars and their homes, a clear reference to the crushed metal sculptures of John Chamberlain. Those sculptures (since destroyed) set out to show that sculpture, like painting, originates with flatness. 'The best proof of sculpture not being sculpture', Morley has said, 'is to take a napkin which is flat, and do what Chamberlain does which is to take it in your fist and to screw it up and now you've got this sculpture which is this flat plane which has been folded'.[37] The actions of manipulating flat planes into

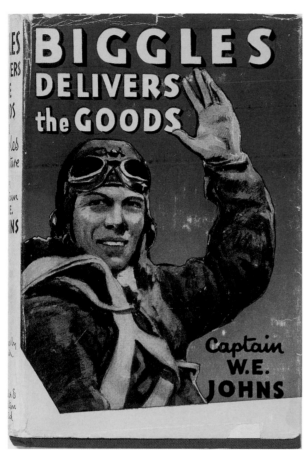

fig. 21
Captain W.E. Johns
Biggles Delivers the Goods, 1952

three-dimensional objects are played out in the floundering vessel of cat. 48 whose sails even look like thick linen napkins that have been folded and unfolded. In fact, the model three-masted clipper on which Morley based his vessel was subjected to even harsher treatment: 'I couldn't do a thing with it', Morley told Brooks Adams, 'so I took the model into the shower with me for two hours, watched it crumple into a ball, and as it dried, I pulled it apart.'[38] Interfering with perfection is as much a part of Morley's intention as preserving it.

Just as Morley often refers to other art in a secret code of impasto, graffiti, stripes, zips, targets, etc., so his recent paintings pay special tribute to one artist, Kasimir Malevich. 'I love him so much', he told Adams, ' but I can't just paint a cross – I have to disguise it'.[39] Malevich is a hero to Morley in the way Lord Byron is a hero to him, and Cézanne. To understand this one first has to understand that for Morley art is 'a kind of substitute heroism'. 'You don't have to be burnt at the stake nowadays', he says, 'but you

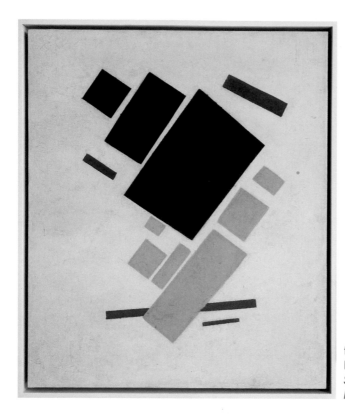

fig. 22
Kasimir Malevich
Suprematist Composition: Airplane Flying, 1914

can be engaged in an activity that can raise certain eyebrows. The strongest artistic will dominates in any period. That is obvious. That artistic will enervates lesser artistic wills but they still won't be the real thing. As a lawyer once said to me: "Malcolm, in New York scum and cream float on the same surface." Good art and bad art float on the same surface. So it is the courage to project artistic will at a very ambitious level that takes it to another possibility'. This is the courage Morley recognizes in all his heroes (including his schoolboy heroes – see fig. 21). Malevich's *Black Square* is an act of heroism that is likened in these paintings to the courage shown by fighter pilots in both World Wars (cat. 52). The analogy between the flat planes of the model parts and the tilting planes of the Suprematist compositions (fig. 22) takes the point a step further, as if in recognition of Malevich's own obsession with flight.

The flat abstract shapes of the wings, fuselage, wheel covers and landing gear are the building blocks of the figurative image flying overhead (cat. 51). They are also forms that are Morley's way of 'keeping in touch with the iconography of abstraction'. Morley's desire

to make 'an abstract art that is real' has never been so explicit. Nor has his admiration for the exploits of his fellow artists. These deceptively simple compositions make stealthy references to the camouflage paintings of Warhol, the sculpted colour of Ellsworth Kelly, the history of papier collé from Picasso to Matisse, the word paintings of Magritte and the pop culture embraced by Roy Lichtenstein. Malevich's act of courage was to accept the simplicity of making paintings that function as 'signs flowing from the creative brain', as he put it. Morley's latest paintings are an example of the courage it takes to work within almost dangerously limited means. 'The less you try to invent', he says, 'the more you invent if you are the real thing. You can't stop being the real thing even if you are doing something like this. So the test is always to find the place where you could not be the real thing.'

He is still testing.

Notes

Unattributed quotations are from conversations with Malcolm Morley in May 2000 and January 2001.

1. Richard Francis in conversation with Malcolm Morley, 1990. Tate Gallery Archive, tape no. TAV 753A

2. Jean-Claude Lebensztejn, *Malcolm Morley*, Reaktion Books, London, 2001, p. 18

3. Marla Prather, *Willem De Kooning Paintings*, National Gallery of Art, Washington, DC, 1994, p. 93

4. Klaus Kertess, 'Malcolm Morley: Talking about Seeing', *Artforum*, vol. 18, no. 10, June 1980, p. 50

5. Michael Compton, 'Malcolm Morley', *Malcolm Morley*, Whitechapel Art Gallery, London, 1983, p. 8

6. 'The Abstract Sublime', *ARTnews* 59, no. 10, February 1961, pp. 38–41; reprinted in Rosenblum, 1999, pp. 72–79 (see note 24)

7. Andy Warhol and Pat Hackett, *Popism. The Warhol '60s*, Hutchinson, London, 1981, p. 18

8. By 1958, Morley had made five North Atlantic crossings.

9. When Florence Barron received *Ideal State,* which had been delivered to her in two pieces with the inner tube of rubber tyre stapled to one edge ready to be inserted between the two panels, her reaction was characteristically blunt: 'Malcolm, Detroit is not ready for this painting.' This is the first time it has been shown.

10. Cited by Lawrence Alloway, 'Art', *The Nation*, 5 June, 1972, p. 739

11. David Sylvester, 'Showing the View to a Blind Man', *Malcolm Morley*, Anthony d'Offay Gallery, London, 1990, p. 13

12. 'Malcolm Morley on Delacroix's *The Death of Sardanapalus*', *The Daily Telegraph*, 13 January 2001, p. A12

13. Alloway 1972, p. 739

14. Sylvester 1990, p. 6

15. Nena Dimitrijevic, interview by Malcolm Morley, *Flash Art*, no. 142, October 1988, p. 76

16. Bruce Kurtz, 'Documenta 5: A Critical Preview', *Arts Magazine*, June 1972, p. 37

17. Francis 1990, tape no. TAV 753A

18. Michael Compton, 1983

19. Sylvester 1990, p. 13

20. Kurtz 1972, p. 37

21. Ibid.

22. Kim Levin, 'Malcolm Morley Post Style Illusionism', *Arts Magazine*, February 1973, pp. 60–63

23. Barnett Newman, *Selected Writings and Interviews*, New York, 1990, p. 100

24. Robert Rosenblum, 'American painting since the Second World War', *On Modern American Art*, New York, 1999, pp. 69–70

25. Lawrence Alloway, 'Malcolm Morley', The Clocktower Gallery, New York, October 1976

26. Nathaniel West, *The Day of the Locust*, New Directions Publications, New York, 1950, p. 185

27. Kertess 1980, pp. 48–51

28. Ibid.

29. Francis 1990, tape no. TAV 752

30. Sylvester 1990, p. 14

31. Ibid., p. 16

32. Norman O. Brown, *Life against Death: The Psychoanalytical Meaning of History*, Wesleyan University Press, Hanover, NH, 1985, p. 72

33. Francis 1990, tape no. TAV 752A

34. Les Levine, 'A flight from and to Atlantis. Malcolm Morley, the last great modernist', *Malcolm Morley*, Musée national d'art moderne, Centre Georges Pompidou, Paris, 1993, p. 257

35. Richard Milazzo, 'Malcolm Morley and the Art of the Incommensurable', *Malcolm Morley*, Galleria d'Arte Contemporanea, Modena, 1998, p. 10

36. *Man Overboard*, 1994; *Racing to the New World*, 1995, *Keepers of the Lighthouse*, 1994 and *Longitude*, 1996

37. Cited in Lebensztejn 2001, p. 177

38. 'Malcolm's Marinara', *Malcolm Morley*, Sperone Westwater, New York, 1999, p. 8

39. Ibid, p. 7

39
Port Clyde, 1990

40
The Flying Dutchman, 1990

42
Shipwreck, 1993–94

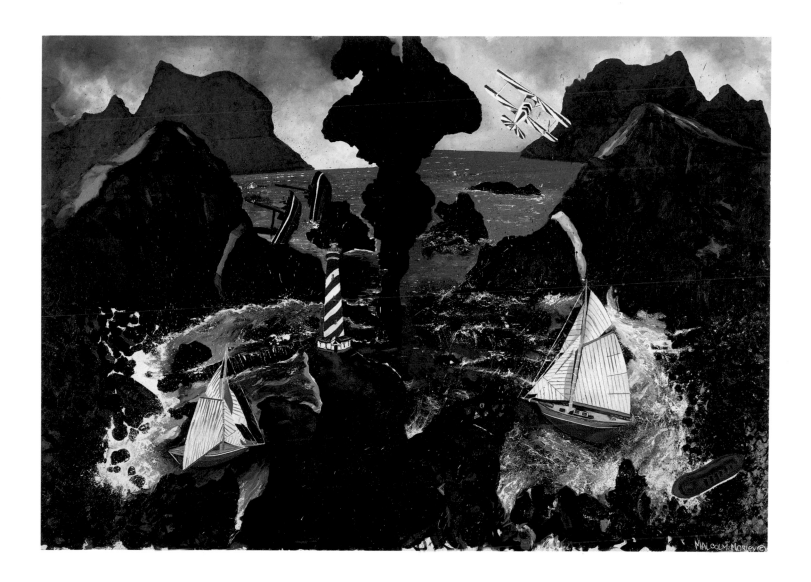

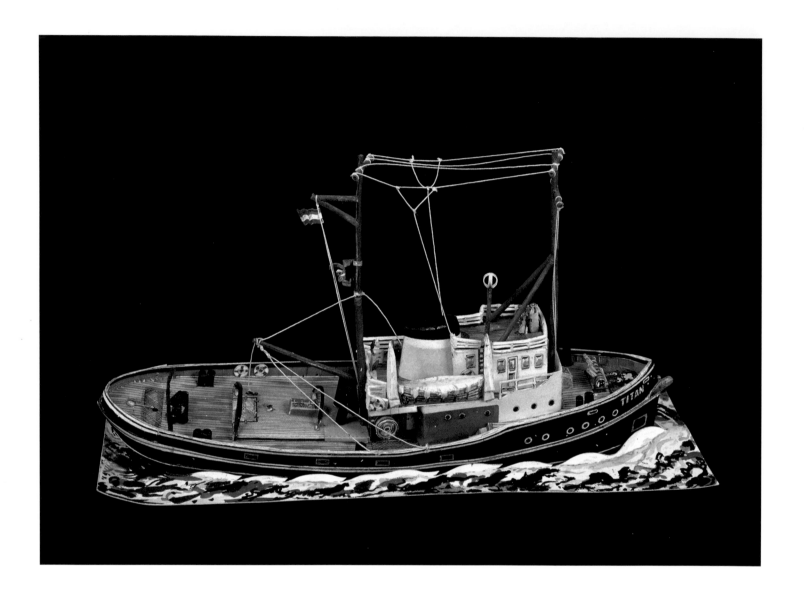

43
Titan, 1994

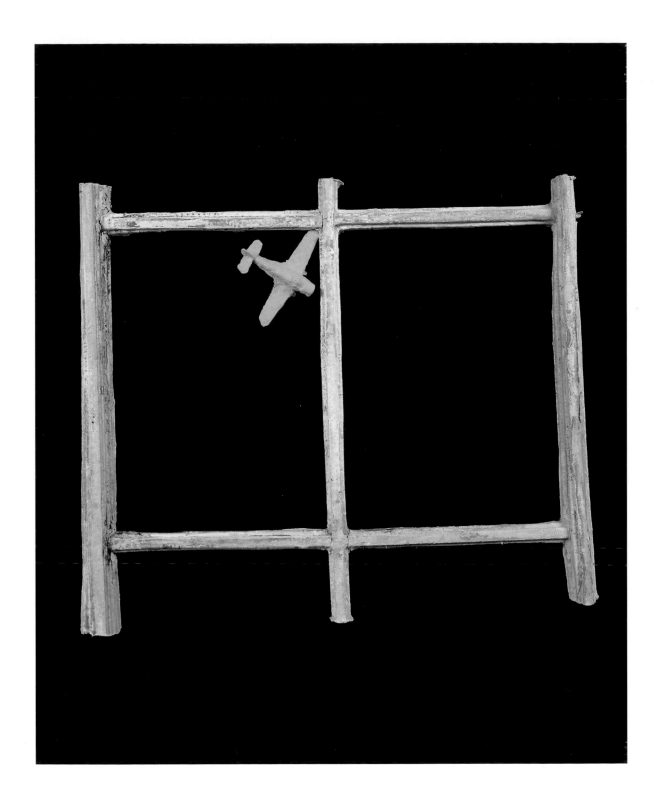

44
White Frame with Yellow Airplane, 1994

48

Floundering Vessel with Blue Whales and Viking Ships, 1998

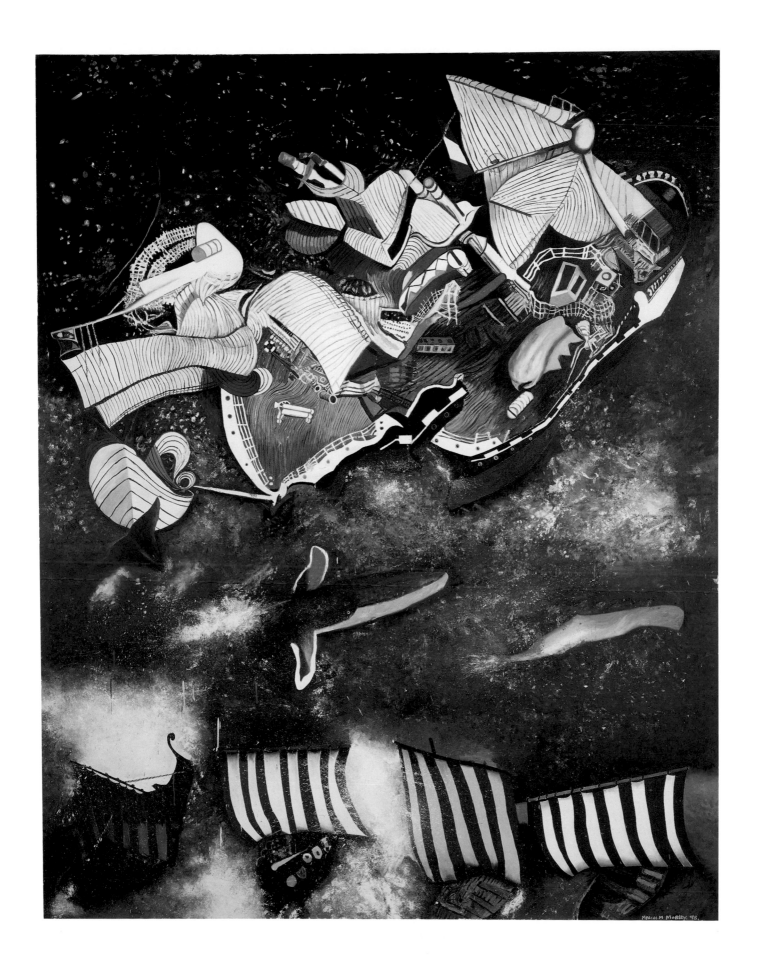

49
Mariner, 1998

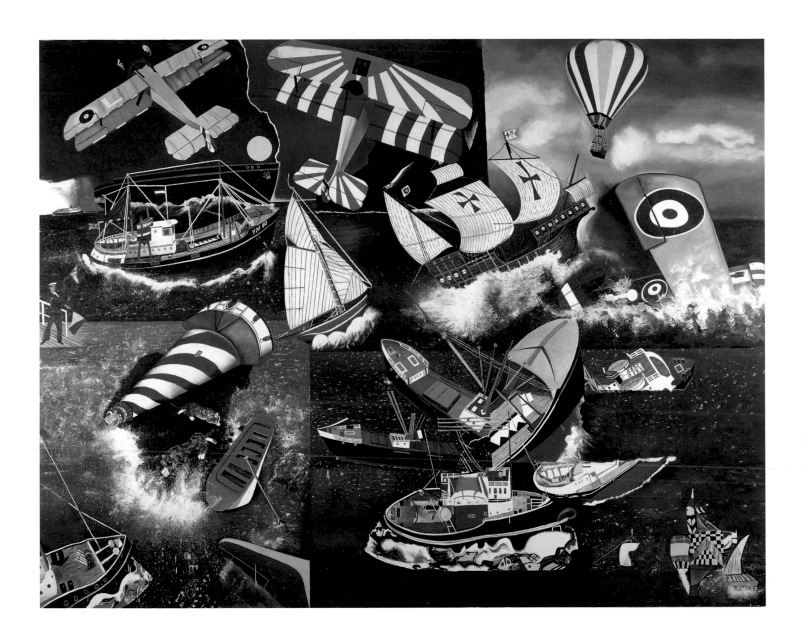

51
Fokker DVII, 2000

Messerschmitt with Spitfire, 2000

53
Nieuport 17, 2000

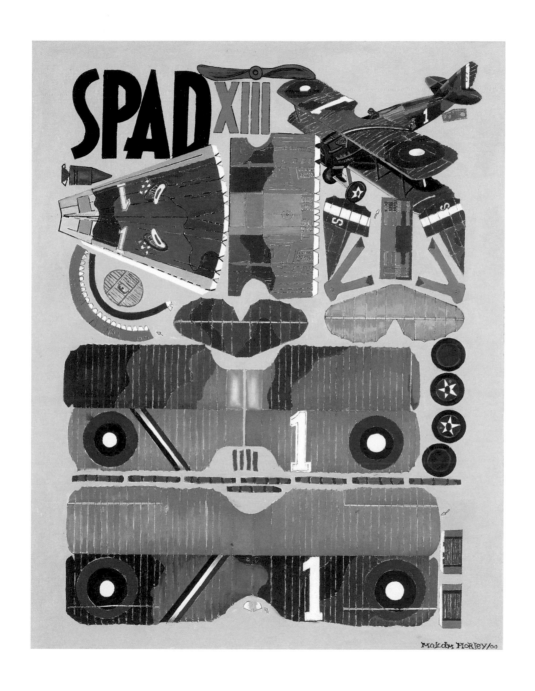

54
SPAD XIII, 2000

55
Albatros with Sopwith Pup, 2001

Malcolm Morley in Conversation with Martin Gayford
December 2000

MG Do you feel like an English artist or an American artist?

MM In my case that's been a problem. I've lived in America most of my adult life – I'm now sixty-nine. I left here at twenty-seven. But I still have pretty much of an English accent, although to English people I may sound a little Australian. I run into a few problems in New York about being an English artist, and I run into problems in England about being an American artist. It's an unfavourable position to be in, because there are more accolades in your native country.

MG Although that may be changing. Three out of four of the people on the last Turner Prize short list were not born in this country.

MM I'm glad to hear that happened. When I won there were letters in *The Times* objecting to my having this prize, as I had been living in New York.

MG In certain respects, for example your interest in psychoanalysis, you are very typical of New York.

MM On one level, yes. But on another level there's a very strong Englishness in me. As my wife Lida puts it, you can take a Brit out of England, but you can't take England out of the Brit. I have a close camaraderie with Turner. And a close relationship to tonal painting, which is very English. The language itself, the spoken language is tonal.

MG Why do you feel such an affinity with Turner?

MM Well, first of all in subject matter. He painted the sea and ships. Also, when I was a kid I lived in Twickenham, in Middlesex, where he lived too. He probably had a cockney accent.

MG Do you sense any other English antecedents?

MM Well, there's Paul Nash. I love those paintings he did in the Second World War, the crashed Messerschmitts in the landscape. I loved those painters at the Royal College who were teaching there – Ruskin Spear, Carel Weight. I think they were terrific painters. It would be very interesting to speculate about what would have happened if I'd stayed in Britain. One of the things that probably wouldn't have happened is the intense psychoanalysis.

MG …which is a key to what you do.

MM That's the guts of my whole life's work, essentially. It was as if I believed I had this fatal flaw, like an Achilles' heel. And I'd accepted it, resigned myself to it. Then psychoanalysis revealed that I did not have to go around with an Achilles' heel. I could integrate myself into myself. It became a wonderful tool for evolving oneself.

MG The Achilles' heel being…

MM One's neurosis. The idea that you could do something actively about it for me was very energizing.

MG There is a view of creativity which holds that it requires something like a neurosis. You need grit in the oyster.

MM I'm glad you brought up that metaphor. It's one I think of from time to time. The bigger the irritation, the bigger the piece of grit, the bigger the pearl. The oyster is wrapping this stuff around the grit to protect itself from its own pain. So emotional injury at an early age, if it can be cultivated, as a pearl is cultivated, becomes a pretty terrific thing.

MG And that was what happened in your case?

MM Yes, in my life. Every child has a terrible time somewhere, but some really have it worse than others. And I had it worse than most. Not that I'm trying to make a claim about it. In fact, I'm saying I turned it to my advantage.

I think children have strong emotions that overwhelm, and they can't do much about them. But if as a child you've had something, then lost it, then you can redeem it as an adult by rendering it as a work of art. I think I can say I have now fully found myself. Maybe not all over, but I think I'm pretty realized as far as my work is concerned.

Now I can do something with it because I have the resources of these powerful emotions – loss, being evacuated, being a refugee, being bombed. We were billeted in other people's houses. Then, when I came back to London, we were hit by a V1. There was a family breakdown. I never knew my father, or who my father was. My mother had a real character disorder. The blame was always on me. I became a delinquent early on, stole a bicycle and stuff like that.

MG Your painting is often crammed with psychic material.

MM Yes, it is. Also one can learn to approach history from a psychoanalytical point of view, and art history as well. So even when one has achieved a reasonably non-neurotic state of being – which is very rare – then you are free to investigate the neurosis of society itself. That is a great tool for an artist, to be in touch with the pulse in that way. But certainly the first order is, physician, cure thyself.

Perhaps that's why there's a great hunger and yearning for painting, especially in the United States. One is reminded of *Brave New World*, where there are these people called savages, who haven't been brainwashed. You could go and visit them, and they were free. I've often thought it would be great to have a country where there were just painters. You could visit it and it would be a way of keeping in touch with primal tendencies and gratifications.

Underlying everything really is the conflict between the pleasure principle and the reality principle. As infants we experience pleasure unmitigated by reality, then repress it to grow up. But we continue to yearn after the fruits of pleasure more than just about anything else. And dream of turning work into pleasure.

There's a built-in guilt for the artist, whose work is pleasure. But we need our artists to find another way, other than dreams or neurosis, back to that supreme joy that we always remember on a subliminal level.

Man is always directed towards the pleasure principle, however he sublimates it into work. Despite what Englishmen might say, they still want that oceanic pleasure. And there's Eros in the middle of one of the most repressed countries in the world – which strikes me as a paradox in itself.

MG Of course you painted a picture of Piccadilly Circus.

MM Yes, and when I then hung a bag of grey paint over the painting, and shot arrows at it, it was almost

as if we were executing Eros. So I take myself as a guinea pig for all of us. I'm doing it for myself, but I know my self is all selves on a certain level. But that painting was also to do with my whole life. I used to hustle on Piccadilly Circus. When I was thirteen I was almost living on the streets. It was really a personal number on Piccadilly Circus.

MG The problem for the person who's actually producing the work, is that it's also very difficult, so you see-saw between pleasure and pain. Dorothy Parker said she didn't enjoy writing, she enjoyed having written.

MM That's very good. I'll second that. Nowadays I'm really enjoying painting. It hasn't always been like that, probably only for the last five or six years. I've been painting since the age of eighteen, now I'm sixty-nine.

MG A painting such as *Christmas Tree – The Lonely Ranger Lost in the Jungle of Erotic Desires* is loaded with psychic freight – it's got so much in it. It's got a dildo in it, a Christmas tree, all manner of charged items. How did the imagery of a painting such as this develop?

MM Intuitively, as I went. It's always guided by pictorial contrasts – in terms of form, colour, soft things and hard things, multiple contrasts on different levels, and a social myth in the middle in the Lone Ranger. It was also a pun on the American obsession with guns.

A painting such as this opens up an enormous amount of stuff. And the viewer doesn't necessarily have to be conscious of it. It's working on you through the central nervous system. It's similar to the idea of somebody giving you a pill. Say somebody drops LSD in your drink. It doesn't matter whether you're communist, gay, conservative, you are going to be

affected for the duration of the dose. Francis Bacon was very involved with the idea that the painting goes directly to the nerves. You can't get it through the head. It goes right to your guts. I believe all great painting does that.

MG As a child you spent a lot of time making models. Did you play with them?

MM No, I never did. Making the models meant solitude. When other children were playing with each other, I was alone making the models. So that started early on, a feeling of isolation.

The point was making the models, and making a better model than the last one. That was very important. They could never be good enough. The turrets turning, the davits of the lifeboats moving.

MG And the one that was blown up in an air raid, as you have described before, was your masterpiece?

MM Yes. That was when I was thirteen. As I said before, one of the strongest emotions you can have as a child is to lose something that you loved. It could be the loss of a parent or the loss of an object. In my case it was the loss of an object. I never knew my father, so that was always a blank space. But the loss of the model ship – I'd really buried that. It surfaced in psychoanalysis. But I was already painting that kind of imagery before connecting it with the loss of the model.

Here's another example. When I was a boy, I was at boarding school in Devon, when I was about eight. The war was on. A Greek tanker had been torpedoed, and the crew had come ashore in a lifeboat. Our whole class was taken down to see this boat which was perched on the rocks in an impossible way with the bows up in the air, and we were allowed to climb up. Inside the boat there were loaves of Greek bread

and life-jackets were floating in it. It was a really powerful image.

Maybe ten years ago, Lida and I were in Tenerife on a watercolour trip, and we came across a cove. We were high up above it looking down. It reminded me of the wreck in Devon, I could see it again. When we went back to the hotel, I made a little model out of paper of the boat and stuck it on the watercolour. That was the first time I did that. It was a remarkable recovery of something powerful that had happened to me as a boy. The Superrealist paintings were trying to repaint that original model that got blown up. But the idea of making literal models started after this affair in Tenerife. It's opened up sculpture for me.

MG The lost model, as David Sylvester put it, was your Rosebud.

MM Yes. So in a way the Germans did me a great favour. I was just about to paint that model vessel, when it got blown up by the V1. It was as if I'd been given Aladdin's lamp. All I had to do was rub it, and try to paint that original ship that could never be reclaimed. So I would never run out of the necessity to paint the image, except it did evolve and it did change.

MG When did you start painting?

MM In the nick, when I reading about Van Gogh in *Lust for Life.*

MG What was it about that book that so affected you?

MM Well, up to then what I knew about art had been much more to do with the Academy. My grandmother, for example, when referring to an artist – if she wanted to give him a high value – would say, 'Oh, you know, he's an RA.' So my idea of art was that it was difficult, hard to do, with modulations in the manner of Alfred Munnings. When I looked at the Van Gogh paintings, they looked to me crude. I felt that was something I could do. To the unsophisticated mind they seemed easier to do, careless.

Watercolour was the first medium I used because one of the wardens – he was a Welshman, the librarian – painted watercolours, beautiful, teeny-weeny pictures. And he would lend me his watercolour paints at night when I was locked up, and he would come and collect them in the morning. So watercolour became for me a very natural thing, like playing the blues for a jazz musician. I'd just go and play the blues with a watercolour.

MG Do you enjoy putting the paint on?

MM There have been periods when I have been repelled by how it feels putting it on, and how it looks.

MG So it's a charged experience?

MM Either way, in terms of anxiety. The ultimate goal is pleasure. But I play Russian Roulette with the idea of getting pleasure. There's also ambition. It's a matter of where you place your ambition. As I put it, dealing with the big issue. And what is that? It's evolving painting in some way. That's not to say that it gets better. It changes. It's different. But there has to be a great desire for power.

MG To do something new.

MM Yes, but it doesn't come out of nowhere, as if nothing has existed before. You can usually find its source, except in some cases, such as Cézanne's, you cannot. That leap that Cézanne made, from Renaissance space to the space of sensation, space through the senses, was tremendous, and you can't find a source for it. He made a quantum leap.

MG Picasso and Matisse were always saying he was their father.

MM Mine too. I always come back to Cézanne. He himself said he was the precursor of an audience that would be invented by his paintings. That's what I mean by the big question.

MG Why did you go to New York in 1958? Did you feel more was happening there in art? Was it because you'd seen the Abstract Expressionist show in London?

MM It was nothing to do with that at all. It was just that I met a young lady on a bus who came from Queens. That was the reason why I arrived in New York, although I'd seen the Abstract Expressionist painters. I went to New York because an opportunity turned up under the guise of romance. But there was no looking back once I got there. I felt like the salmon going upstream to spawn. The thing didn't work out with the young lady, and after I'd been in New York for a while I went up to Canada with the hope of getting a teaching job. I ended up working as a waiter in a club where they did curling – it's a Scottish sport. Then I went back to New York and got a job in a book store, I was in the philosophy and Bible section. I got a bonus for selling more copies of Oswald Spengler's *Decline of the West* than anyone else.

Then I found myself getting more involved in the art world. I discovered the Cedar Street Tavern where the Abstract Expressionists hung out – which was quite exciting. When I arrived Pollock had just died, so it was mainly De Kooning and Franz Kline who were the big stars. But uptown they were still showing fifth rate School of Paris junk, and most of the artists were doing day jobs. So there was a fervour there.

Next I met Barnett Newman. He came to my studio, and at that time I thought I was doing my version of Abstract Expressionism, and the first thing he said when he looked at my paintings was, 'Oh, I like your sense of light'. He wasn't referring to light as in Impressionism, but the idea of the artist's light. I had the image of being a coal-miner wearing a lamp on your helmet, lighting everywhere up as you went around from an inner light. That was the first time I'd come across that scale of thinking, really philosophical thinking.

The Royal College of Art was a dreadful place in terms of education. You didn't learn a damned thing. What you learned was how to hold your drinks with the teachers. I arrived in New York without ever hearing who Marcel Duchamp was. It never came up. So this was a big revelation to me. It was the metaphysics of Barnett Newman's thinking that attracted me a great deal. But when I did the first Superrealist paintings I felt I had betrayed Newman. I felt ashamed that I had to do these paintings. And I arrived very late at my own opening, it was almost closing. And they said, Barnett Newman came in and waited for an hour to see you. He loved your paintings.

The other person who had a very big effect was Salvador Dalí. He loved the idea that he was painting photographs from the unconscious, and I was painting conscious photographs.

MG So New York was more intellectually exciting.

MM And I couldn't come back here. I had a past I wanted to move away from.

MG There was something very attractive about America for many British people in the 1950s and '60s, artists among them. Did it seem glamorous?

MM Not for me. I thought I was following some journey. Emotionally I was very disturbed. A lot of internal conflicts. Then I discovered psychoanalysis –

which I took to as a duck takes to water and that seemed to be one of the anchoring factors in New York.

MG The very process of painting caused you intense anxiety. You've also said that at one stage each picture was partly a project to overcome the difficulties that had cropped up in the previous one.

MM Yes, you keep thinking you've solved that problem, then a new one turns up. Now if there's a problem in the work it's in the area of the content, not in the process.

MG But these technical anxieties were obviously wrapped up with the other anxieties.

MM With the emotional ones, because they were part of finding the aesthetic of it. Finding the process was the biggest struggle of all. Cézanne said that the artist's heaven is to have a perfect process, and of course he was seeking that throughout, and finally arrived at his diagonal brushstroke. In themselves those brushstrokes were sort of a grid. But they always went in one direction, forward.

MG How did the use of a grid affect the way you worked?

MM When I started to work with the grid, I found out that it had to go sideways and backwards and forwards. It didn't really matter. Essentially, the drawing was in the grid itself. It's a Renaissance idea, and familiar from my training in London, my only difference was that each piece was finished as I went along, whereas with Sickert it was used as the under drawing. Once he achieved that, the painting was treated overall. I was digital rather than analogue. So that really opened up a way I could go, and something I could do.

As an art student you painted the figure, then you painted the background, so the background isn't quite as interesting somehow. There was a hierarchy of figure and ground. Now, working in the way I do, there is no such hierarchy. So in that sense it's a very democratic way of working. That enabled me to control the paint itself, so that I could maintain an equal distribution of pigment throughout the surface.

The ideal, as far as I'm concerned, is a paint surface like a sheet of plate glass. For me, that's the highest aesthetic quality in painting. I don't follow this rule in everything I've done, but in general I feel that if you turn a painting sideways and look along it, you shouldn't see things sticking out.

MG Not like a Van Gogh.

MM There should be no marks like troughs and muddy tracks. No signs of the sides of the brush. I hate ridges in painting, where the brush has left a mark like a trough in the earth where a car has run through it. I am repelled by ridged painting.

MG You've said that you are a painter of oil paint over canvas, so that is another of your stipulations.

MM Yes, I once planned a magazine called 'Painting', or possibly just 'Oil Painting', not just any kind of painting. I paint wet on wet within a square in a grid. And by using very light brushes, even watercolour brushes, the paint can lie on wet paint without going into it. It just coalesces.

Another fundamental point is that I'm a painter of sensations, of seeing, not from memory of seeing. If one is painting a still life, and you have a cup here and the canvas there, even looking from here to there involves memory, even if it's only two seconds, it's still memory. So what I endeavour to do is to have what I'm painting right dead set in front of me, so

there's no looking back and forwards. I'm painting what I'm seeing, that sensation, immediately. Another part of my process is that I don't want to change the nature of the medium from what it is in the tube.

MG So you don't like it thinned out.

MM No, I wet it just a little bit to move it with the tip of a palette knife dipped in medium, because there are never large amounts of paint that I'm using at any one time. I need soft brushes, but if the amount of paint gets too large the brush is not strong enough to manipulate the paint. So I paint in small quantities of paint, then I can use pretty, small, soft brushes, rather than a big brush that would dig into the paint and create troughs. Also, there's no right or wrong way up in this way of painting. It doesn't matter.

MG As when you painted the ships in the 1960s upside-down.

MM Exactly. Doing it upside-down originally was just to get at the canvas, because I don't want to paint with the angle of vision up or down, but always just in front. Each square of the grid is a separate picture, with the same intensity, and then they are all joined together.

MG Sickert, who followed the French tradition, believed painting should be a mosaic of opaque pastes, that is, no glazing. You seem to agree.

MM Yes, no glazing. All the representation is done through opaque paint. Say you want to represent a lace curtain, instead of trying to represent its transparency, you look for its tonal change. So it's very much involved with tonality within the colour. That is why I finally evolved this method of luminous tones, by mixing complementaries. Let's imagine a bowl

in a dark room. You still sense the yellowness of the bananas in the dark. Why is that? What's happening? Yellow with a slight bit of purple tones it down, but still leaves its yellowness. You can tone blue by using a little orange, its complementary. You would think orange would brighten up blue. But it doesn't. It darkens it. But there's a narrow envelope that you have with this tonal change. Because if you go too far it becomes brown.

I remember visiting the Delacroix house in Paris where they have a palette on which he's mixed a whole row of grey tones, about twenty of them, out of colour, not black and white. And they each had luminosity. Each little tone looking like a pearl on the palette.

MG There does seem to be a connection through to Sickert in your work.

MM Oh, there certainly is. I happily acknowledge it. Camberwell was a hotbed of Sickertism. I'm a little bit brighter than Sickert. He never got out of the English colour.

MG It's all a bit dingy.

MM Very grey. And he seldom painted really big paintings.

MG And you returned from abstraction to producing recognizable imagery – like Sickert, who also worked from found images – subjects such as ships that would make sense to the artistic man in the street.

MM When art movers would come to my studio when I was doing Abstract Expressionist kind of painting, they'd just take them out and load them into the van. When I started doing Superrealist paintings, they'd put on white gloves – 'Be careful, Bill, this is

what I call a really good picture'. I thought, my worst fears have come true: the man in the street loves this work. But I guess I want it to work on all levels, not just the level where you have to have a PhD in art history to understand. Barnett Newman, who I love, means nothing to the man in the street. I can't put that into a comfortable place in my mind.

MG How do you arrive at what you paint, the subject matter?

MM What comes to mind when you say subject matter is, what's painterly – that is, what's painterly in terms of my temperament, to quote Cézanne. One's temperament might undergo developments and changes, so there isn't a fixed idea of what is painterly. Some painters might have one, the way cockroaches are born fully formed. For me, my painterly temperament underwent changes.

But what is painterly? For example, Robert Ryman was asked why he doesn't use colour, just white. He said colour would interfere with the painting. I thought that was a terrific thing for him to say. For me, I like to use all the stops – if you imagine an array of tubes of paint being very much like an organ. Then I'd be able to employ all the interrelationships of primary colours, secondary colours, tertiary colours; and have them in clusters that lead to other clusters. And the subject matter, or the image itself, could be so strong that you don't notice the construction of the picture itself – the way a building doesn't hit you first with its construction.

Some people think my work has a pronounced sociological bent in its imagery. In South America, for example, artists think I was something of a social realist, painting the cruise ships and people having dinner underneath. You can see it from that point of view too.

I picked the race-track as a subject because it offered everything I wanted to do in paint. It allowed

thousands of figures in different colours, and so on. When I picked that image from a poster I wasn't looking at that image as a South African race-track, I was looking at it as being very painterly. And I hired a sign-writer to do the lettering underneath, and covered the painting while he did it. So he didn't see the painting at all. That was a homage to Duchamp who had a sign-writer paint the pointing hand in *Tu'm*. So there was a dialogue included in that. But now I see the painting, and I'm very happy to describe it as Malcolm's X. What a great pun of the unconscious! So there does seem to be something beyond what I'm conscious of at the time of painting.

MG So the subject matter is provided by your subconscious?

MM By my subconscious, plus my conscious desire to paint what's painterly, in other words what isn't boring.

MG Looking at the paintings that come after the Superrealist phase, it looks as though you're putting everything in, dreams, urges, fantasies, free associations.

MM You know the story about Andy Warhol when he was young going to visit Eleanor Ward, the dealer who ran the Stable Gallery? He asked her how he could become a famous artist. She asked, 'What do you love most in the world?' He answered, 'Money'. She said, 'Paint it'. What I loved most in the world was those models I used to make as a kid.

MG Something like that opens up unlimited psychic connections.

MM Unlimited is a good word. It opens up a tremendous underworld, very deep. You still have to keep the big question in mind, and find the source for fertilizing it. Picasso said a wonderful thing, 'All I ever did was

put everything I loved into my paintings.' I suppose you could make an exception of *Guernica*, but it took me quite a while to arrive at the source. I was still involved with the quest for the Holy Grail of art. But I eventually gave up the quest for art about art in favour of a search for art about something. What should the something be? Something that you have a very strong emotion about.

MG Later on, your trains and boats and planes are often involved in disasters and accidents.

MM And that of course dovetails with pictorial changes. It was as if I was putting the early work through its own baroque period.

MG What was the process of thought and feeling that led from the Photo-Realist phase to the next one?

MM Well, one factor was that when I was doing these pictures I felt I'd found something that I wanted to keep doing forever. It certainly was a nice move from pop to post pop. And by the end of the year there were about a hundred painters doing it. And I felt it had been taken away from me. So I felt compelled to destroy it, rather than have them take it way from me.

MG But what were you up to, consciously, in a picture such as *Los Angeles Yellow Pages*, where you are moving from Superrealism into something looser and freer. The image is breaking up.

MM I was very influenced by Jasper Johns, and I think that's apparent, in protractor drawing of the curves. I tore the book, I used it as a palette, then photographed the whole thing. Cut it up and painted it. That started to open up that famous little remark of Jasper Johns, 'Do something. Then do something else to it'.

MG That painting's got Abstract Expressionist brushwork, and Superrealism.

MM I think my objective for a long time had been to synthesize everything. But the baroque phase was rather a small period in my career.

MG It lasts six or seven years. It's an eruption of emotion.

MM Yes. There is a tremendous amount of repression in the earlier, Superrealist pictures. They are masterpieces of repression. They were divided into tiny pieces, and I only did so much each day. I learned an enormous amount about painting by doing them.

MG What kind of things?

MM You develop your own alphabet, leading to a pictorial language. It was as if I was inventing a whole personal alphabet. A lot of the paintings of that period are still to do with reaction. You get a lot of mileage out of reaction, a lot of energy. It's far more difficult to act, because that's to do with loving. Now I'm making paintings out of loving. I consider myself very lucky to be at that point. A lot of people don't survive.

Chronology

1931

Malcolm John Austin Morley is born on 7 June to Dorothy Gertrude Morley of 3 St Jude Street, Stoke Newington, London. The house belongs to his maternal grandmother Catherine Amelia Morley. His mother later marries a former Welsh miner, and her son takes his name, Evans. The family later moves to Highgate.

1939–45

During the war, Morley is evacuated to Tankerton Boarding School in Salcombe, Devon. A few years later, he is sent to the Burstow Naval College in Surrey, but runs away.

1945–46

Signs on as a galley boy on the tug boat Salvonia. The North Atlantic crossing, from Gravesend to Cape Breton, takes ten days. Morley breaks his kneecap and is hospitalized in Cape Breton. He is sent back to England on a passenger ship.

1948–51

After a year at Hewel Grange reformatory school in Birmingham, Morley receives a three-year sentence for housebreaking and petty theft which he serves at Wormwood Scrubs prison in London. He is released after two years for good behaviour. During his time there he takes a course in drawing and, encouraged by one of the warders, paints in watercolour. 'In a sense, the cell was my first studio.' After his release, he joins an artists' colony in St Ives, Cornwall, where he takes a job as a waiter.

1952–53

Attends Camberwell School of Arts and Crafts, London. The teaching reflects the spirit of the Euston Road School. The staff includes Martin Bloch and Philip Matthews. 'Cézanne was the very first contact I had with art when I went to Camberwell – you heard nothing else but Cézanne.'

1954–57

Attends the Royal College of Art, London, where his teachers include John Minton and Carel Weight. By his own admission, most of his education there 'was by osmosis'. Among his fellow students are Richard Smith, Joe Tilson, Peter Blake and Frank Auerbach.

1955–57

Takes part in three annual exhibitions of *The Young Contemporaries* at the RBA galleries in Suffolk Street, London.

1956

Receives British Arts Council Travelling Exhibition Prize.

1957

Visits New York where he marries for the first time. Returns to London for his graduation from the Royal College of Art. Around this time he changes his name back to Morley.

1958

Moves to New York where he works in a restaurant. Over the next few years he meets Barnett Newman, Cy Twombly, Roy Lichtenstein, Andy Warhol, etc. Rents a studio on Henry Street, on the Lower East

Side. 'I didn't know how I wanted to paint and I didn't know what I wanted to paint.'

1960–61

Begins working in a variety of abstract styles influenced by American painters, Cy Twombly in particular.

1964

Shows a group of abstract paintings at the Kornblee Gallery, New York. Rents an apartment on 20th Street. Winter: begins work on a group of monochrome paintings based on photographs of battle cruisers and sailors using acrylic and inks. Around this time, he visits Richard Artschwager's studio and the work he sees there makes an immediate impression on him, particularly the artist's practice of squaring-up the image.

1965–66

Recommended by Roy Lichtenstein, he takes up a teaching post at Ohio State University, Colombus. *SS Amsterdam in front of Rotterdam* (cat. 13) is painted in his house in Colombus where it is admired by the critic Lawrence Alloway.

1966

Spring: the 'Superrealist' paintings of ocean liners are shown for the first time in *The Photographic Image*, an exhibition at the Solomon R. Guggenheim Museum, New York, organized by Lawrence Alloway.

1967

February: exhibits recent paintings of ocean liners and cabin interiors at the Kornblee Gallery where they are admired by Barnett Newman. Andy Warhol passes on to Morley a commission for a portrait of Sargent Shriver's daughter. The project falls through but Morley goes on to paint several commissioned portraits which are done from photographs taken under his direction.

1967–69

Teaches at the School of Visual Arts in New York.

1969

February: one-man exhibition at the Kornblee Gallery. Among the works shown are *Coronation and Beach Scene* (cat. 16) and *Vermeer: Portrait of the Artist in his Studio* (cat. 17).

1970

Paints *Race Track* (cat. 18), the last of the Superrealist paintings.

1971

Taken up by the OK Harris Gallery in New York, run by Ivan Karp. Leaves shortly afterwards because of Karp's refusal to show his new works. Begins to paint in watercolours.

1972

August: represented by several large paintings in *Documenta V*, Kassel, Germany. Takes up a teaching post at the State University of New York at Stony Brook.

1973

October: one-man show at the Stefanotty Gallery, New York, which includes shaped canvases, some of which are free-standing. Around this time he experiments with what he calls 'Social Sculpture' with the aim of questioning the role of the artist in society and in the world of art. He also abandons the grid and gives up acrylic in favour of oils. 'Oil allows more diversity, and it's denser and wetter. Modulation. I want modulation. Acrylic is for a more homogenized surface. I want to allow as much variety as possible.' The same year he publishes a portfolio of five lithographs, *Arles/Miami*. The edition is pulled at the Shorewood Atelier in New York.

1974

January: commissioned by the New York Cultural Center to paint a work *in situ*, Morley begins *The painting with separate moving parts that are self-generating*. After the museum refuses to let him work inside the building, Morley films the completion of the work in a truck parked next to the Center.

August: one-man show at the Stefanotty Gallery, New York.

1976

October: first paintings on the themes of disasters and catastrophes are included in a one-man exhibition at the Clocktower Gallery, Institute for Art and Urban Resources, New York. The curator, Lawrence Alloway, describes them as 'rough as a belch'.

1977

June: takes part in *Documenta VI*, Kassel. Travels to Berlin on a grant from the German Academic Exchange Program (DAAD). One of the works he paints there is *The Day of the Locust* (cat. 28). Falls ill with blood poisoning and is hospitalized in Zurich.

December: moves to Tampa, Florida where he spends the next eighteen months. Produces a large number of watercolours of animals, birds and plants painted from nature at the Tampa Zoo. Many of these serve as the basis for new works in oils.

1979

April: shows a group of the catastrophe paintings from the past five years at the Nancy Hoffman Gallery, New York. Spends the summer at St Jean-Cap-Ferrat in the South of France. Morley's interest in toys becomes increasingly visible, and reaches a new level of intensity in *Christmas Tree – The Lonely Ranger Lost in the Jungle of Erotic Desires* (fig. 14). 'The thing about so-called "toys" is that there is an unconsciousness in society that comes out in its toys. Toys represent an archetype of the human figure.'

1981

January: attends the opening of *A New Spirit in Painting*, Royal Academy of Art, London during his first trip to England after an absence of more than twenty years. Continues to paint in watercolour: 'I feel that in a sense I am the reincarnation of all English watercolour painting.'

April: first of four one-man shows at the Xavier Fourcade Gallery, New York.

Visits Arizona, and travels to Greece and Crete. From now on he makes regular trips abroad.

1983

June: major retrospective exhibition organized by the Whitechapel Art Gallery, London. It is also seen in Basel, Rotterdam, Washington, Chicago and New York.

1984

Autumn: Morley is announced as the first winner of the Turner Prize, awarded by the Tate Gallery for 'the greatest contribution to art in Britain in the previous twelve months'.

1985

Buys an abandoned Methodist church on Long Island, a move that brings new stability to his life. 'I've never lived right. It's taken a long time to find a way. Like a dog who turns round and round before he lies down.'

1989

June: marries Lida Kruisheer.

November: Dorothy Morley (now Dorothy Jones) dies at her home in Exeter. Morley returns to England for his mother's funeral. 'My search for the Holy Grail ended when I made contact with my English roots. I could integrate that need with an emotional need.'

1990

September: one-man show at the Anthony d'Offay Gallery, London. Among the exhibits is a series of nine bronze sculptures on the subject of warfare cast from cardboard and wax models.
Morley is granted American citizenship.

1991

Around this time, Morley begins making paper models, incorporating them into his paintings as three-dimensional objects. 'I make all the models for my work out of watercolour paper painted with watercolour. They take the form of ships, airplanes and lighthouses set in a still-life format, except in my work apples are sailing boats.'

1991–92

Malcolm Morley: Watercolours, a travelling exhibition organized jointly by the Kunsthalle Basel and Tate Gallery, Liverpool.

1993

June: major retrospective exhibition organized by the Musée national d'art moderne, Centre Georges Pompidou, Paris. It travels to the Centre Régional d'Art Contemporain Midi-Pyrénées, Toulouse-Labège.

1997

April: exhibits a series of oil paintings and watercolours on the theme of battleships, freighters, etc. at the Galerie Daniel Templon in Paris.

1999

February: one-man show at the Sperone Westwater Gallery in New York. His recent work includes *Mariner* (cat. 49), which is the first painting of his to be acquired by the Tate Gallery, London.

2000

Begins a series of paintings based on model kits of airplanes, which he had first come across at an antique air show in New York. 'I think people lost a really great space when they couldn't paint angels in the sky anymore.'
December: a group of these works is shown at the Xavier Hufkens Gallery in Brussels.

2001

June: a major retrospective opens at the Hayward Gallery, London.

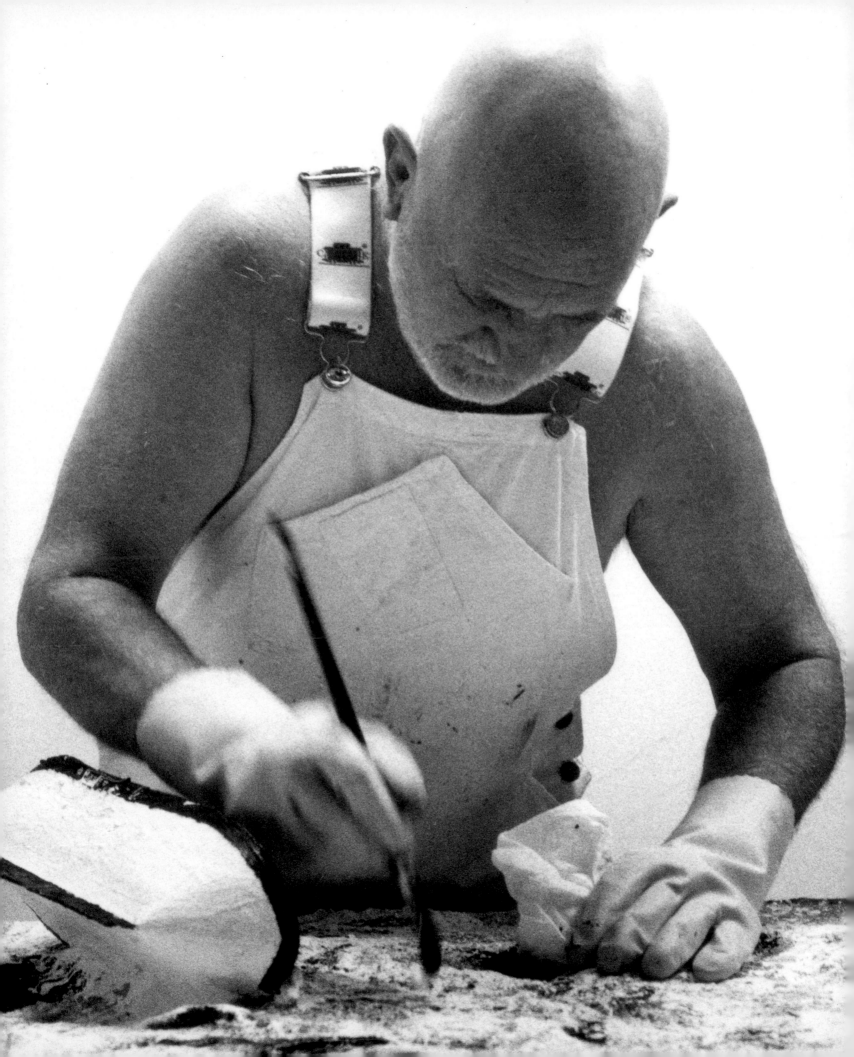

Select Bibliography

The most comprehensive bibliography is published in *Malcolm Morley*, Musée national d'art moderne, Centre Georges Pompidou, Paris 1993. It is arranged chronologically.

Monographs

Jean-Claude Lebensztejn, *Malcolm Morley*, Reaktion Books Ltd, London, 2001

The author of this first general study worked closely with the artist over a period of four months and was given wide access to archives and other documentary material. His book is particularly revealing about the later paintings, which are discussed in detail and generously reproduced.

Richard Milazzo, *Malcolm Morley: The Art of the Superreal, the Rough, the Neo-Classical, and the Incommensurable*, Editions d'Afrique du Nord, Tangier, 2001

Exhibition Catalogues

The Photographic Image, with an introduction by Lawrence Alloway, the first critic to defend Morley and one of the best writers on his early paintings, Solomon R. Guggenheim Museum, New York, 1966

Malcolm Morley, with short text by Lawrence Alloway, The Clocktower Gallery, New York, 1976

Malcolm Morley: Paintings 1965–82, with essay by Michael Compton, Whitechapel Art Gallery, London, 1983

Malcolm Morley, with essay and interview by David Sylvester, Anthony d'Offay Gallery, London, 1990

Malcolm Morley: Watercolours, with essay by Richard Francis, Tate Gallery, Liverpool, 1991

Malcolm Morley, with essays by Klauss Kertess and Les Levine, Musée national d'art moderne, Centre Georges Pompidou, Paris, 1993 (in English and French). This catalogue also has an extensive chronology.

Malcolm Morley, with essays by Brooks Adams and Enrique Juncosa, Fundacion La Caixa, Madrid, 1995 (in English and Spanish)

Malcolm Morley: Dipinti / Acquarelli / Disegni / Sculture, with essay by Richard Milazzo, Emilio Mazzoli Galleria d'Arte Contemporanea, Modena, 1998

Malcolm Morley, with essay on recent paintings by Brooks Adams, Sperone Westwater, New York, 1999

Malcolm Morley Picture Planes, with essay on recent paintings by Brooks Adams, Xavier Hufkens Gallery, Brussels, 2000

Articles

Lawrence Alloway, 'The Paintings of Malcolm Morley', *Art and Artists*, February 1967, pp. 16–19

Lawrence Alloway, 'Morley paints a picture', *Art News*, Summer 1968, pp. 42–44, 69–71

Lawrence Alloway, 'Art', *The Nation*, 29 December 1969, pp. 740–42

William C. Seitz, 'The Real and the Artificial: Painting of the New Environment', *Art in America*, November–December 1972, pp. 58–72

Valentine Tatransky, 'Morley's New Paintings', *Art International*, October 1979, pp. 55–59. The author was a student of Morley's.

John Yau, 'Malcolm Morley Bids Farewell to Crete', *Parkett*, no. 3, December 1984, pp. 6–17

Vicki Goldberg, 'Malcolm Morley, Keeping Painting Alive', *New York Times*, 14 March 1993, p. H31

Enrique Juncosa, 'Malcolm Morley or Painting as Adventure', *Parkett*, no. 52, 1998, pp. 67–76 (in German and English)

Jean-Claude Lebensztejn, 'Seasickness', *Parkett*, no. 52, 1998, pp. 89–95 (in German and English)

Interviews

Klaus Kertess, 'Malcolm Morley: Talking about Seeing', *Artforum*, Summer 1980, pp. 48–51

Sarah McFadden, interview with Malcolm Morley in 'Expressionism Today: An Artists' Symposium', *Art in America*, December 1982, pp. 58–75, 139–41

'Malcolm Morley: The Outsider', *Omnibus*, BBC TV broadcast, producer Mike Mortimer, 1985

Nena Dimitrijevic, 'Malcolm Morley', *Flash Art*, October 1988, pp. 76–80

Richard Francis, taped interviews of his conversations with Malcolm Morley, 1990, Tate Gallery Archive. These tapes, which are not included in other bibliographies, repay the effort of listening to them.

David Sylvester, 'Showing the View to a Blind Man', *Malcolm Morley*, Anthony d'Offay Gallery, London 1990, pp. 13–18

Robert Storr, 'Let's Get Lost: Interview with Malcolm Morley' in *Art Press*, May 1993, pp. E3-E7

List of Works

1 (p. 17)
Aesop's Fables, 1961
oil and pencil on canvas
243.8 × 214 cm
Wadsworth Atheneum, Hartford,
CT. Gift of the Estate of Marcus
Bassevitch

2 (p. 18)
Necklace, 1961–62
oil and mixed media on canvas
152.4 × 152.4 cm
Private Collection
Photo: Neil Budzinski

3 (p. 21)
Alexander Nevsky, 1962
oil and mixed media on canvas
243.8 × 213.4 cm
Guy and Nora Barron
Photo: Ned Redway

4 (p. 19)
Submarine, 1962
oil and pencil on canvas
183 × 152.5 cm
Mel Juffe Collection, New York

5 (p. 22)
Malcolm Morley at the Seaside, 1963
oil on canvas
25 × 25 cm
Guy and Nora Barron
Photo: Tim Thayer

6 (p. 30)
French Navy, 1964
oil on canvas
32.4 × 88.3 cm
Lori and Marc Barron
Photo: Tim Thayer

7 (p. 23)
Ideal State: The New Atlantis F.B., 1964
oil on canvas with rubber tyre
235 × 239.4 × 4.4 cm
Guy and Nora Barron
Photo: Tim Thayer

8 (p. 28)
HMS Hood, Foe, 1965
Liquitex and ink on canvas
105.4 × 105.4 cm
Private Collection
Photo © Christie's Images

9 (p. 29)
HMS Hood, Friend, 1965
Liquitex and ink on canvas
106 × 106 cm
Baldwin Gallery, Aspen, Colorado

10 (p. 31)
Night Rider, 1965
oil on canvas
106.7 × 182.9 cm
Guy and Nora Barron
Photo: Tim Thayer

11 (p. 42)
*SS Independence with Côte
d'Azur*, 1965
Liquitex on canvas
100.6 × 127 cm
The Detroit Institute of Arts.
Gift of anonymous donor

12 (p. 41)
Ship's Dinner Party, 1966
Magnacolor and Liquitex on canvas
210 × 160 cm
Centraal Museum, Utrecht

13 (p. 45)
*SS Amsterdam in front of
Rotterdam*, 1966
Liquitex on canvas
161.3 × 212.1 cm
Collection of Irma and
Norman Braman
Photo courtesy Sperone Westwater,
New York

14 (p. 43)
Diving Champion, 1967
Liquitex on canvas
127 × 152.4 cm
Guy and Nora Barron
Photo: Tim Thayer

144

15 (p. 46)
Beach Scene, 1968
Liquitex on canvas
279.4 × 228.2 cm
Hirshhorn Museum and Sculpture
Garden, Smithsonian Institution.
Gift of Joseph H. Hirshhorn, 1972
Photo: Lee Stalsworth

16 (p. 47)
Coronation and Beach Scene, 1968
Liquitex on canvas
227.2 × 228.6 cm
Hirshhorn Museum and Sculpture
Garden, Smithsonian Institution.
The Joseph H. Hirshhorn
Bequest, 1981
Photo: Lee Stalsworth

17 (p. 49)
*Vermeer: Portrait of the Artist in
his Studio,* 1968
Liquitex on canvas
266.7 × 221 cm
The Eli and Edythe L. Broad
Collection, Los Angeles

18 (p. 51)
Race Track, 1970
Liquitex on canvas
170 × 220 cm
Ludwig Museum Budapest –
Museum of Contemporary Art
Photo © József Rosta

19 (p. 59)
Goodyear, 1971
oil on canvas
180.3 × 180.3 cm
Collection of Robert Lehrman,
Washington, D.C.

20 (p. 65)
Los Angeles Yellow Pages, 1971
Liquitex and encaustic on canvas
233 × 203 cm
Louisiana Museum of Modern
Art, Humlebaek, Denmark

21 (pp. 62 – 63)
New York City Postcard, 1971
Liquitex and wax on canvas
157.5 × 595.5 cm
Astrup Fearnley Collection,
Oslo, Norway
Photo: Tore H. Røyneland

22 (p. 61)
Safety is Your Business, 1971
oil, wax and Liquitex on canvas
223.5 × 279.4 cm
Collection of Robert Lehrman
Washington, D.C.

23 (p. 67)
School of Athens, 1972
Liquitex on canvas
170.2 × 247.7 cm
Stefan T. Edlis Collection
Photo © Mark R. Hatch – Dave
Marlow Studio

24 (p. 69)
Untitled Souvenirs, Europe, 1973
oil on canvas with mixed media
264.2 × 184.2 cm
The Virginia and Bagley Wright
Collection

25 (p. 70)
Disaster, 1974
oil on canvas with knife and pieces
of rubber
91.4 × 137.3 × 5 cm
Collections Mnam/Cci – Centre
Georges Pompidou
Photo: Philippe Migeat
© Photothèque des collections
da Mnam/Cci

26 (p. 71)
SS France, 1974
oil and mixed media on canvas
with objects attached
203.8 × 152.4 × 3.17 cm
Private Collection

27 (p. 73)
Age of Catastrophe, 1976
oil on canvas
152.4 × 243.8 cm
The Eli and Edythe L. Broad
Collection, Los Angeles

28 (p. 75)
The Day of the Locust, 1977
oil on canvas
239.3 × 199.5 cm
The Museum of Modern Art,
New York, Bernhill, Enid A.
Haupt, and Sid R. Bass Funds, 1987
Photo © 2001 The Museum of
Modern Art, New York

29 (p. 77)
Out Dark Spot, 1978
oil on canvas
184.5 × 251 cm
Collection Onnasch

30 (p. 79)
The Day of the Locust III, 1979
oil on canvas
121.9 × 121.9 cm
Private Collection, Birmingham,
Michigan
Photo courtesy Sperone Westwater,
New York

31 (p. 85)
Arizonac, 1981
oil on canvas
203.2 × 266.7 cm
Courtesy Mitchell-Innes & Nash,
New York
Photo courtesy Sperone Westwater,
New York

32 (p. 87)
*Cradle of Civilization with American
Woman,* 1982
oil on canvas
203 × 238.5 cm
Collections Mnam / Cci – Centre
Georges Pompidou
Photo: Photothèque des collections
da Mnam / Cci

33 (p. 88)
*The Injuns are Cuming - The Officer
of the Imperial Guard is Fleeing,* 1983
oil on canvas
203 × 280 cm
Astrup Fearnley Collection,
Oslo, Norway
Photo: Tore H. Røyneland

34 (p. 89)
Seastroke, 1986
oil on canvas
152.4 × 248.9 cm
The Marieluise Hessel Collection,
on permanent loan to The Center
for Curatorial Studies at Bard
College, New York
Photo courtesy Sperone Westwater,
New York

35 (pp. 90 – 91)
Aegean Crime, 1987
oil and wax on canvas
198.1 × 404.5 cm
Courtesy PaceWildenstein,
New York
Photo: James Dee

36 (pp. 92 – 93)
Night on Bald Mountain, 1987
oil and wax on canvas
198.1 × 330.2 cm
Collection Onnasch

37 (p. 95)
Albatross, 1988
oil on canvas
200.5 × 228.5 cm
Astrup Fearnley Collection,
Oslo, Norway
Photo: Tore H. Røyneland

38 (p. 97)
*Black Rainbow over Oedipus at
Thebes,* 1988
oil and wax on linen
289.6 × 323.2 cm
Hirshhorn Museum and Sculpture
Garden, Smithsonian Institution.
The Joseph H. Hirshhorn Bequest
Fund, 1991
Photo: Lee Stalsworth

39 (p. 107)
Port Clyde, 1990
patinated bronze, edition AP 2 / 3
25.4 × 61 × 6.4 cm
Courtesy of the artist and Sperone
Westwater, New York

40 (p. 109)
The Flying Dutchman, 1990
encaustic and assemblage on wood
139.7 × 105.4 × 12.7 cm
Collection Anne and Anthony
d'Offay, London

41
Crashed Sopwith Camel, 1992
paper and balsa-wood model with
watercolour
10.2 × 73.7 × 45.7 cm
Collection of the artist
Courtesy Sperone Westwater,
New York

42 (p.111)
Shipwreck, 1993-94
oil on canvas
142.2 × 198.1 cm
Stefan T. Edlis Collection
Photo courtesy Sperone Westwater,
New York
Photo: Dorothy Zeidman 1994

43 (p. 112)
Titan, 1994
paper model with watercolour
and string
19.1 × 12.7 × 33 cm
Collection of the artist
Courtesy Sperone Westwater,
New York
Photo: Steve Leible

44 (p. 113)
White Frame with Yellow Airplane, 1994
encaustic on paper with steel
support
45.7 × 53.3 × 3.2 cm
Collection of the artist
Courtesy Sperone Westwater,
New York
Photo: Steve Leible

45
Crushed Freighter, 1995
paper model with watercolour,
encaustic and string
6.4 × 17.8 × 76.2 cm
Collection of the artist
Courtesy Sperone Westwater,
New York

46
Ocean Liner, 1996
paper model with watercolour
and string
38.1 × 20.3 × 160 cm
Collection of the artist
Courtesy Sperone Westwater,
New York

47
Tankerton Bay, 1997
four holographic plates each
in anodized metal holder
27.9 × 35.6
Private Collection, Belgium
Courtesy Xavier Hufkens,
Brussels

48 (p. 115)
*Floundering Vessel with Blue Whales
and Viking Ships*, 1998
oil on linen
259 × 201.9 cm
Columbus Museum of Art, Ohio:
Museum Purchase, The Shirle and
William King Westwater Fund
and donations made in memory
of William King Westwater by his
family and friends

49 (p. 117)
Mariner, 1998
oil on canvas
294.6 × 375.9 cm
Tate: Purchased with assistance
from the American Fund for the
Tate Gallery, 2000
Photo courtesy Sperone Westwater,
New York

50
Spitfire, 1999
paper model with watercolour
11.4 × 49.5 × 40.6 cm
Collection of the artist
Courtesy Sperone Westwater,
New York

51 (p. 118)
Fokker DVII, 2000
oil on linen
182.9 × 129.5 cm
Courtesy of the artist, Sperone
Westwater and Xavier Hufkens,
Brussels

52 (p. 119)
Messerschmitt with Spitfire, 2000
oil on linen
200.7 × 282.6 cm
Courtesy of the artist, Sperone
Westwater and Xavier Hufkens,
Brussels

53 (p. 120)
Nieuport 17, 2000
oil on linen with wood attachments
106.7 × 71.1 cm
Private Collection, Belgium
Courtesy Xavier Hufkens,
Brussels
Photo courtesy Sperone Westwater,
New York

54 (p. 121)
SPAD XIII, 2000
oil on linen
91.4 × 71.1 cm
Courtesy Xavier Hufkens,
Brussels
Photo courtesy Sperone Westwater,
New York

55 (p. 123)
Albatros with Sopwith Pup, 2001
oil and enamel on linen
238.8 × 335.3 cm
Courtesy of the artist and
Sperone Westwater, New York
Photo: Steve Leible

List of Figures

fig. 12 (p. 40)
Holland-Amerika Lijn brochure,
1955
Courtesy Museum Enschedé,
Haarlem, The Netherlands

fig. 13 (p. 53)
The Illustrated London News,
17 October 1942, front page
© The Illustrated London
News 2001
Photo © Mike Fear 2001

fig. 14 (p. 55)
Malcolm Morley
*Christmas Tree – The Lonely
Ranger Lost in the Jungle of Erotic
Desires*, 1979
oil on canvas
183 × 274.5 cm
Private Collection
Photo courtesy Sperone Westwater,
New York

fig. 15 (p. 56)
The Illustrated London News,
27 November 1915, pp. 696 – 97
© The Illustrated London
News 2001
Photo © Mike Fear 2001

fig. 16 (p. 81)
Théodore Géricault
*An Officer of the Imperial Horse
Guards Charging*, 1814
oil on canvas
349 × 266 cm
Musée du Louvre, Paris
Photo © RMN – Hervé
Lewandowski

fig. 17 (p. 82)
Jackson Pollock
Guardians of the Secret, 1943
oil on canvas
122.9 × 191.5 cm
San Francisco Museum of Modern
Art. Albert M. Bender Collection.
Albert M. Bender Bequest Fund
Purchase
© ARS, NY and DACS, London
2001
Photo: Don Myer

fig. 18 (p. 83)
Malcolm Morley
Macaws, Bengals, with Mullet, 1982
oil on canvas
304.8 × 203.2 cm
Mitchell-Innes & Nash, New York
Photo courtesy Sperone Westwater,
New York

fig. 19 (p. 99)
The Illustrated London News,
22 March 1941, pp. 1, 2
© The Illustrated London
News 2001
Photo © Mike Fear 2001

fig. 20 (p. 100)
Malcolm Morley, *Hollywood Film
Stars and their Homes*, 1974
oil and aluminium
dimensions variable
Photo courtesy the artist

fig. 21 (p. 101)
Captain W.E. Johns
Biggles Delivers the Goods, 1952
Hodder and Stoughton, London,
front cover
Reproduced by permission of
Hodder and Stoughton Limited
Photo courtesy of the Trustees of
the Victoria & Albert Museum,
London

fig. 22 (p. 102)
Kasimir Malevich
*Suprematist Composition: Airplane
Flying*, 1914
oil on canvas
58.1 × 48.3 cm
The Museum of Modern Art,
New York. Acquisition confirmed
in 1999 by agreement with the
Estate of Kasimir Malevich and
made possible with funds from
the Mrs John Hay Whitney
Bequest (by exchange)
Photo © 2001 The Museum
of Modern Art, New York